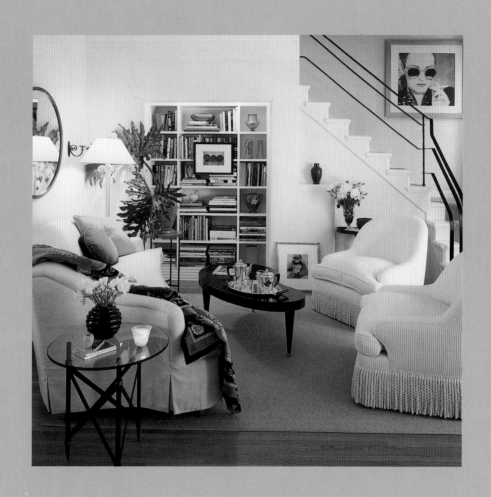

CALIFORNIA
DESIGN LIBRARY

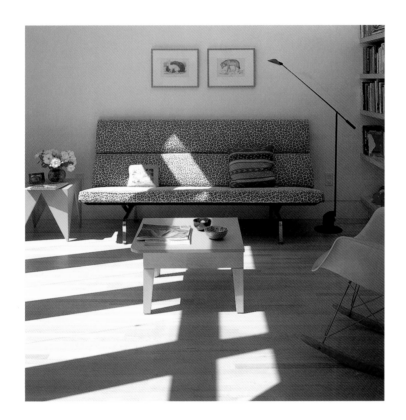

LIVING ROOMS

Diane Dorrans Saeks

CHRONICLE BOOKS

SAN FRANCISCO

For my son, Justin, with love, always. —*D.D.S.*

Printed in Hong Kong

Book and Cover Design:
Madeleine Corson Design, San Francisco

Cover Photograph:
Interior design by Michael Berman, Michael Berman Design, Los Angeles.
Photograph by Grey Crawford.

Title Page:
Architecture and interior by Michael Sant, Sant Architects, Venice, CA.
Photograph by Grey Crawford.

Library of Congress Cataloging-in-Publication Data available.

ISBN 0-8118-1309-6

Distributed in Canada by:
Raincoast Books
8680 Cambie Street
Vancouver BC V6P 6M9

10 9 8 7 6 5 4 3 2

Chronicle Books
85 Second Street
San Francisco
California 94105

www.chroniclebooks.com

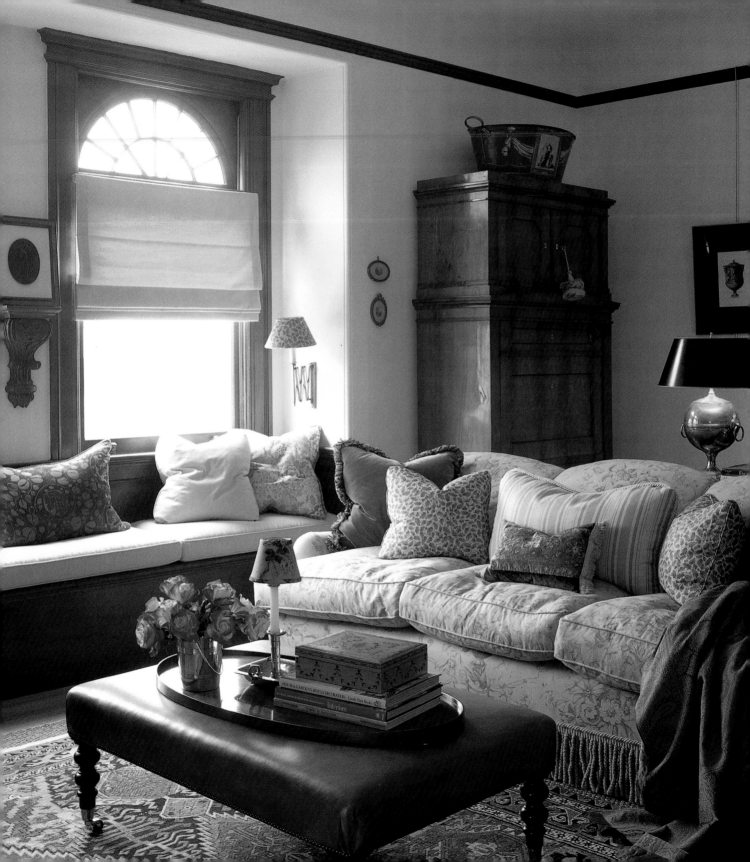

A CLASSIC DESIGN APPROACH

The freshest and finest interior decor in California celebrates individuality, gives more than a passing glance to design history, and revels in comfort and charm. ⚲ For those *soi-disant* experts who imagine that Los Angeles dotes on pneumatic furniture in white rooms and puffed-up sofas with karate-chop pillows, all suffused with Hollywood glamour and flea-market mania, here are some beautifully livable rooms. For those who believe that San Francisco revels in (horrors!) starchy traditional decor, we have a few great rooms. ⚲ Today, theme design is passé and the tyranny of one-style-fits-all is over. California interior designers who are truly creative and professionally adroit no longer strive to impose a singular style on their clients. Rather, decorators and design stores alike provide a framework for clients and encourage them to make educated, personal furnishing decisions. ⚲ The days are gone when California decorating clichés such as badly proportioned copies of Michael Taylor's whacking-big sofas or rote copies of Shabby Chic's first relaxed (sloppy!) chairs could interest even the design illiterate. Extreme exaggeration is no longer appealing. Design correctness doesn't count. Even astute Shabby Chic has moved on to a more tailored, controlled look. ⚲ Authenticity is valued over pallid copies. The real hands-on thing is favored over paint-by-numbers design and mere surface decoration. "Creating comfort and visual pleasure is the goal at home — not adhering to rigid rules of decorating or just one look," said designer Michael Moore, a partner in Mike Furniture, the San Francisco design store that sells a tightly edited range of updated classical chairs, sofas, and lighting. "This is true today — and will be equally valid in ten or 20 years. Home should not be a stage set." ⚲ Moore, like other top California designers, appreciates good design from many epochs. Creating a period room is not the point. ⚲ "Classicism in design never goes out of style — there will also always be an admiration for French design of the late eighteenth century, and Jean-Michel Frank's designs from the thirties and forties, and Hepplewhite, Sheraton, and the Adam brothers," said Los Angeles interior designer Michael Smith, whose Santa Monica store, Jasper, is a favorite with Los Angeles design connoisseurs. ⚲ "No matter the age we live in, clean-lined and versatile furnishings of any period will always be the bones of a room," Smith said. ⚲ Classics — whether

Gustavian chairs, Biedermeier chests, Noguchi lamps, a Chippendale-style chair, a Regency mirror, Japanese altar tables, Roy McMakin dressers, or Alvar Aalto's sofas — are also the best investments because they don't date. The ease and grace of their lines afford many design options. Using them in pared-down settings or mixing them with idiosyncratic pieces — Venetian painted chests, Stickley fumed-oak chairs, Mexican folk crafts, or a Noguchi coffee table — brings energy and humor to rooms. ⚭ Whichever style trajectory a living room takes — neoclassical, fifties revival, carefully delineated contemporary, thirties glamour, or Arts & Crafts rustic — designers and store owners agree that interior design must be personal,

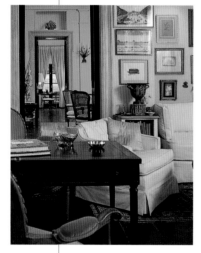

appropriate, comfortable, and functional. Furniture that is not friendly, well-crafted, and sensuous is history. ⚭ The best and brightest West Coast interior designers opt for a refreshing blend of old and newish styles in living rooms. Expensive paintings coexist with flea-market trinkets, contemporary art with fine photography, handcrafted pottery with machine-made objects, and vintage textiles with today's best synthetics. ⚭ "Interior design that looks right is a whole amalgam of styles and design details that please you," agreed Southern California designer Thomas Callaway, whose own updated California Colonial-style house in Santa Monica has many admirers. ⚭ "We have the whole history of furnishing to inspire us," Callaway said. "The days of one 'In' look are truly over. I always appreciate simplicity. And I like to let fine-quality materials like wood and stone speak for themselves." ⚭ Callaway admires the honest beauty of a well-laid parquet floor, a carved picture frame, or an old, well-used table. ⚭ Welcoming armchairs are today's iconographic piece of furniture, added Callaway, because they're satisfyingly self-centered. Unlike sofas, you don't have to share them — and you can move them around and set them just-so to please yourself. ⚭ Trend-setting interior decor stores in California often bring together a remarkably diverse range of furniture styles, looks, new color tonalities, prices, and furnishing fashion attitudes. ⚭ Other emporiums appeal to the senses with a mix of luxurious bed linens, colorful glassware, and handmade furniture in tactile materials and eye-pleasing hues. Luxury

now comes in many guises. For some, it means collecting one-of-a-kind handcrafted rugs, and for others, it's indulging in handwoven silken textiles, a velvet throw, custom-made lamps, or sink-into overstuffed sofas. ⚬ A new sophistication has come to craft, and contemporary ceramics and glass by California artists have gone from artsy-craftsy, loving-hands-at-home to refined and remarkably elegant. ⚬ Despite common misperceptions, truly avant-garde, never-seen-before design movements like those that flourished in the thirties and forties barely exist in California today. New West Coast living rooms almost invariably pay homage to time-honored styles and earlier eras. Familiar furniture is reassuring. ⚬ Gump's director, Geraldine Stutz, believes that grace, comfort, and individuality are the key words in home decor. Furnishing choices are made to please oneself, not for status or to keep up with fashion. ⚬ "This is a time when we all need to surround ourselves with beauty and comfort," Stutz said. "Quality and luxury that represent good value will continue to be important. People want design, materials, and style that will last." ⚬ "House and home present the real portrait of who you are," Stutz said. "That's true from California to Connecticut. People are confident about expressing their own tastes rather than following rigid old rules. An eclectic design approach gives us room to experiment, reinvent traditions, and learn." ⚬ And so in California, Anthony Hail's urbane living room on Russian Hill and Michael Smith's Santa Monica penthouse are miles apart but soul mates in their love of luxurious fabrics, proper posture, and out-of-the-ordinary antiques. ⚬ "Style is not about how much you spend," said trend-setting San Francisco designer John Dickinson. "Style is not what you do, but rather how you do it. Style takes confidence, consistency, and consideration." ⚬ Barbara Barry's tailored monochromatic scheme in Los Angeles and Stephen Shubel's relaxed decor in Berkeley have an affinity — a clearly expressed sense of appropriateness and welcome. Studied simplicity is the way for some of California's great design minds, while others whoop it up with gilt, Empire treasures, and luxe. ⚬ Poetic, not prosaic, the living rooms on these pages show California designers' quests for new design expressions. Enjoy and appreciate them all. PAGE 6 The living room in a San Francisco Edwardian house opts for comfort over trendiness. Design: Patrick Wade and Stephen Brady. OPPOSITE In Beach Alexander's Sonoma house, Gustavian, French provincial, and Russian antiques coexist happily.

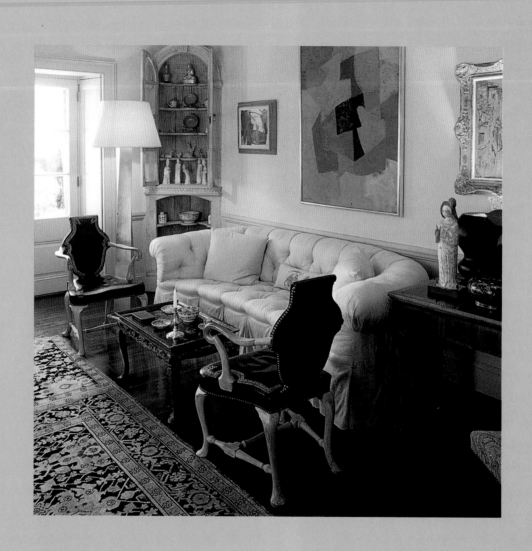

It must be said up front — there is no one California look, no single California style. The very best California interior design is highly individual, often idiosyncratic, and always passionately completed. In avoiding decorating clichés, West Coast talent takes many directions. Most often it is a trip back in time. Michael Smith finds his inspiration in luscious fabrics, off-beat colors, and superb compositions of antiques and paintings. Barbara Barry downplays color, appreciating the power and pleasure in subtlety and understatement. Michael Berman admires the crisp geometries of forties and thirties styles — and reinvents for today. Barbara Barry commented that she admires a "grab bag" approach to design, which is prevalent in the culture today. Ten influential California designers together paint a rich and inspiring portrait of California interiors. OPPOSITE Classic design by Monterey designer Frances Elkins.

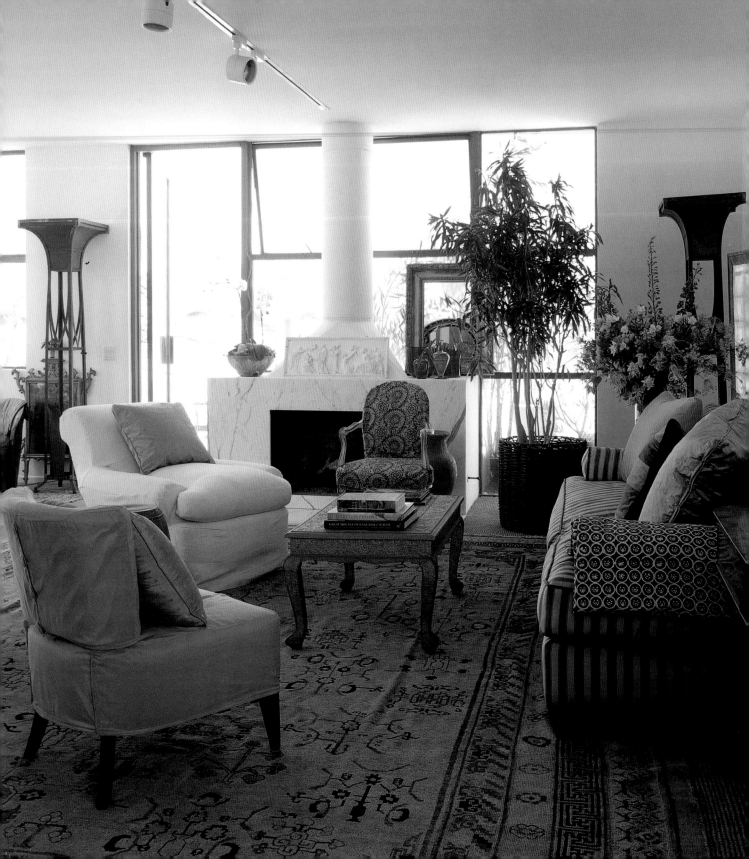

Michael Smith's penthouse is part California Cool, part Grand Tour. The young designer, the favored decorator of many tasteful Hollywood types, has a particular fondness for glamorous-but-old-shoe furniture and off-the-beaten-track antiques, and an aversion to slick, hyper-styled decor. ⚲ For himself, he experiments with challenging colors like orange, *eau de Nil*, buttercup yellow, shocking pink, turquoise, petrol, and tan to offset his white walls and give his rooms a bit more edge. ⚲ Smith's domain at the top of a modernist building measures out at 2,400 square feet, but the living room and dining room seem to gobble up more than their share of the space. (A seldom-used kitchen, two small-but-chic bedrooms, and an Hermes-orange study are squeezed into the back.) ⚲ This is non-thematic design. Smith considers his design self portraiture. "Theme design — any decor you can instantly name and codify — is absolutely anathema to me," said Smith. "My goal is always to make my work personal and evocative of the people who live there. I design so that the rooms can grow and change and evolve over time without needing redecoration." Into this white, floating space — an airy box with daylong light — have come and gone a Portuguese sideboard, a Danish neoclassical bookcase, raffia-covered chairs, Persian vases, Venini glass, Eames chairs, a William III-style sofa, a Belgian marquetry table, and lots of books and paintings. ⚲ It's welcoming, whether a guest is in a swimsuit and sandals, a silk cocktail dress and Manolo Blahnik shoes, or a beautifully cut Giorgio Armani suit. Eschewing the clichés of Los Angeles decorating — a tendency to slickness, impatient instant decor, and an overload of kitsch — Smith heads off in more recherché, eccentric directions. Perhaps most surprising, Smith's penthouse is a hop-and-a-skip from the razzmatazz of Santa Monica beachfront and its hordes of in-line skaters, historic Muscle Beach, and noisome traffic. Michael Smith follows his heart, taking his guests to other realms and unexpected visions. In six months it may change — for him, design is never static.

OPPOSITE & ABOVE Michael Smith's Santa Monica living room is rather like a Roman penthouse — except that it looks toward the Pacific Ocean rather than the Borghese gardens. Sofas striped in turquoise and gray silk and cushioned with bright pillows of chartreuse and saffron sari silk have a Brighton-esque, festive air. On the left, great Edwardian club chairs are covered in Belgian linen slipcovers. Klismos chairs, Venetian glass, and Swedish chairs covered in hand-blocked Indian fabrics add to the cosmopolitan color.

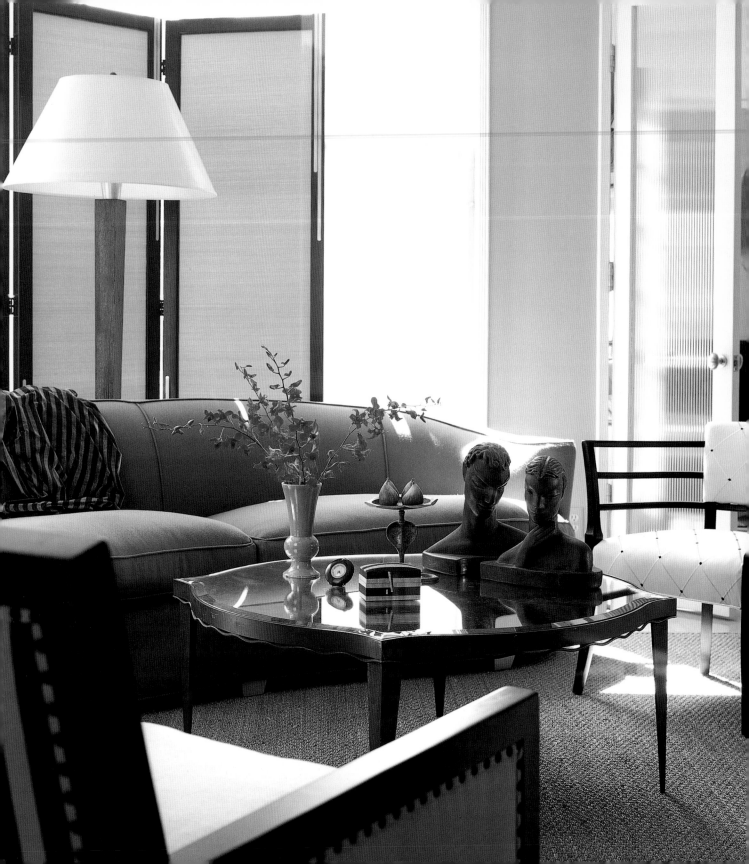

MICHAEL BERMAN

A HOUSE IN LOS ANGELES

As one of his design inspirations, interior designer Michael Berman lists the work of John Dickinson, San Francisco's revered interiors and furniture designer who died in 1983. Berman admires the clean, sculptural, direct lines of Dickinson's work. ☿ In the early eighties, the young Berman worked in New York with interior designer Angelo Donghia, an early acolyte of John Dickinson and his plaster tables and lamps. These seventies design icons and Dickinson's skirted table in galvanized metal often made guest appearances in Donghia's decor. ☿ Berman is drawn to beautifully controlled, elegant interiors. With an innate sense that using an unnamable, smudgy tone can make a room more interesting, the designer carefully modulates his color palate. ☿ Berman has a particular fondness for certain muted browns, ivory, and shadowy greens. He's partial to acid-green and chartreuse (with real bite), delicious eggplant, and soothing grays, all outlined with ebony, just-back-from-the-laundry white, and a slightly tinted ecru. ☿ "I choose colors that are paled-down rather than shocking," noted Berman, who shares his house with Lee Weinstein, a clinical psychologist. "For my clients, I like to work with colors that they can live with for a long time." ☿ The fabrics he selects tend to be smooth and sensuous, a soothing wrap for his shapely furniture. Ribbed cotton chenille with thick bullion cording, natural canvas, silk velvet, taffeta, and vintage woven textiles are among his favorites. ☿ "I like a look that is reminiscent of the glamorous thirties and forties, but updated, not a slavish copy," said Berman. ☿ It's glamour without the glitz or hard edge. Berman said he is a scavenger by nature and mixes periods and styles. "The luxury and comfort are inspired by the forties, but I see this design as more restrained, less fussy, and less ornamented," said the designer. ☿ Berman, like other Los Angeles designers, thinks that rooms come alive when old and new, lavish and not-so, intermingle. He may spend $75 on a dining chair or $500 on a piece of studio pottery if it moves him. He uses vintage and contemporary photography in his rooms whenever it is appropriate. ☿ Michael Berman's interiors have a certain sparseness, but they are nonetheless very comfortable. His own living room, shown here, is an oasis of calm in a busy life. ☿ Michael Berman's Hollywood Modern furniture, lighting, and accessories for the design company ROOMS is available through the designer.

OPPOSITE In the living room of his 1937 Streamline Moderne house in the Hollywood Hills, Michael Berman favors colors like celadon, butterscotch, and cream. The low-key-but-sexy colors are the perfect foil for the ebonized silhouettes of his chairs. Increasing the glamour quotient here: Berman-designed tall "JMF" lamp, "Tamarind" sofa, and "Warner" club chairs. At right, a vintage Paul Frankl chair. The screen was salvaged from the old Bullock's Wilshire store. Rush matting and simple woodwork keep the thirties homage firmly anchored in the present.

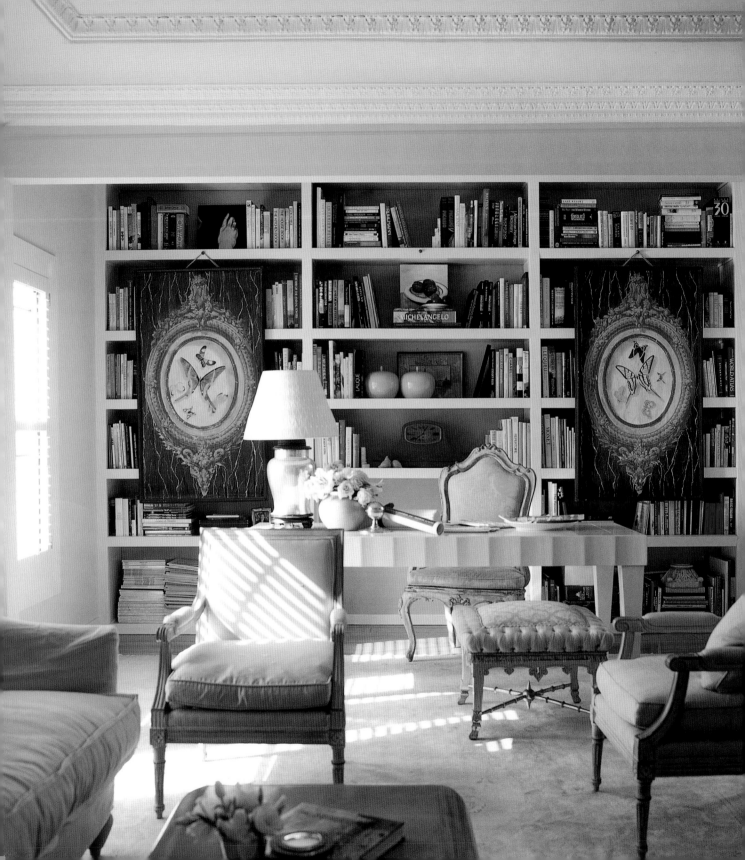

Los Angeles interior designer Barbara Barry believes that true luxury is not to be found in elaborate decorating, over-the-top decor, or a riot of pattern and color. ☿ "Luxury can be the simplest things, such as a soothing color palette, garden roses in a lovely old crystal vase, freshly ironed sheets," said Barry, who grew up in Southern California. "Luxury today is a tranquil room, with comfort for you and for your guests. It's subtle pleasures like silk lamp shades, silk velvet pillows, sterling instead of stainless steel." ☿ Barry said that she prefers sofas to be 84 inches long, a size that's perfectly amenable to seating two. But perhaps even better are four club chairs around a tea-height table or a down-filled ottoman. ☿ "It's such a wonderful human act to sit in your own armchair, your feet on an ottoman, a good reading lamp behind you, and an absorbing book in your hand," said Barry, who also designs rugs, furniture, lamps, tableware, and fabrics. ☿ "A comfortable armchair is the ideal place for relaxing, enjoying a conversation, and immersing yourself in a favorite pastime, such as writing letters, knitting, embroidery, or reading to your child," Barry said. ☿ The designer, known for her clean-lined and tailored interiors, usually takes a reductionist approach to decorating. "'Less is more' is a modern concept," she said. "I like just a few carefully chosen things on a table or a mantel. I prefer an edited look—no clutter. You can always add more as time goes by." ☿ Barry said she seldom chooses patterned fabrics, opting to let the furniture, fresh flowers in a monochromatic or crystal vase, and even the people create the pattern and the focus of a well-composed room. Colors that make appearances in her rooms tend to be subtle gradations of celadon, taupe, ivory, parchment, chartreuse, eucalyptus green, sepia, oxblood, mustard,

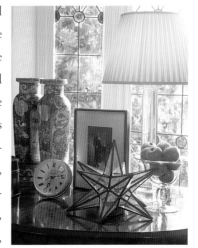

and every possible variation of white. ☿ Pure forms are her ideal in furniture. That often translates into neatly proportioned sofas, a tufted chair with refined, attenuated legs, a prim little table, a slender lamp, a bold bookcase, a Parsons-style bedside table with shelves and a drawer. ☿ "I like a room that ranges wide for historical reference," Barry said.

OPPOSITE In Barbara Barry's 1940 deco-style house, color is turned down a notch, the better to reveal the shapely silhouettes of her chairs and the graceful lines of her ivory-lacquered table. The lamp is by Donghia. Throughout the house the designer likes to arrange what she calls "small moments of beauty" with flowers, black-and-white photography, books, candlesticks, antique silver and glass, architectural fragments. Her living room furniture was chosen for well-mannered proportions and versatility. Chairs with tailored slipcovers can double as dining chairs.

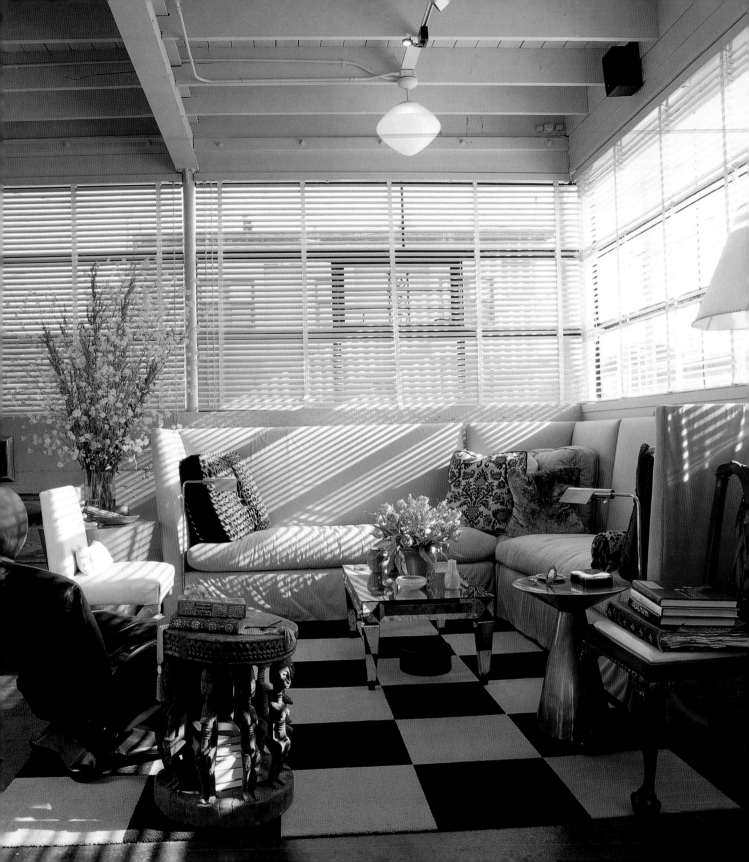

Designer Gary Hutton knows a lot about evolving an interior, letting it reflect a changing taste, new attitudes, life going forward. His own live/work studio has transmuted from all-white and monastic to richly detailed and personal. ℥ Ten years ago, Hutton loved the rigor, purity, discipline, and simplicity of his modernist, all-white studio in the Mission District of the city. Today, the room has texture, colors, and objects to entertain the eye and give the room a sense of comfort and history. ℥ "I was really inspired by this boxy building, which had been built in 1946 with a sort of factory aesthetic and no architectural detail," said Hutton. ℥ "I liked the experience of having carte blanche, and started with just a few pieces of furniture and no frills," he recalled. "I liked editing everything down to essentials, making everything count, rejecting anything that seemed superfluous." ℥ On his path from minimalism, Hutton started collecting. First a Biedermeier chest. Then sculptures and California plein-air paintings with elaborate gold frames. His eye was seduced by Arts & Crafts pottery in muted tones, a cartoony Japanese chair, rich fabrics, an elaborate and lively African table. ℥ Then one day Hutton got bored with white and wanted some color in his surroundings. "I discovered that there was a tyranny to minimalist and that I probably don't have the discipline to maintain such an environment," mused Hutton. "I like possessions and beautiful things about me. I love the stories and events attached to my collections." ℥ Minimalism, Hutton discovered, did not allow the intrusion of his personal experiences. ℥ "I found a rich greige paint by Donald Kaufman — DKC12 — and appreciate the vitality this mutable tone gives my room," said the designer. "Donald Kaufman's paints are wonderfully lively. Some days this gray/taupe

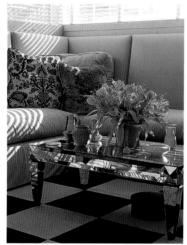

looks mauve, other times it looks pale beige, and evenings it's soft and soothing." ℥ Hutton has stayed true to an uncluttered frame of reference. "I still like my room crisp and focused, but the furniture and collections give me a sense of place that was missing when the room was spare," he said. "Now these pieces I've collected give me great pleasure."

OPPOSITE & ABOVE Gary Hutton's sofa is slipcovered in textural greige Henry Calvin cotton moire. The carpet is a checkerboard of commercial-quality beige and black wool "tiles"—for pattern without real pattern. The "Wink" chair upholstered in black leather is by Toshiyuki Kita. At right, Hutton's own "Ciao" table is crafted in fiberglass with an antique bronze finish. John Dickinson's carved animal-foot chair with cream leather upholstery. The legs of the chair seem about to pounce, giving the room a certain tension. On the chair, part of Hutton's collection of design books purchased at auction.

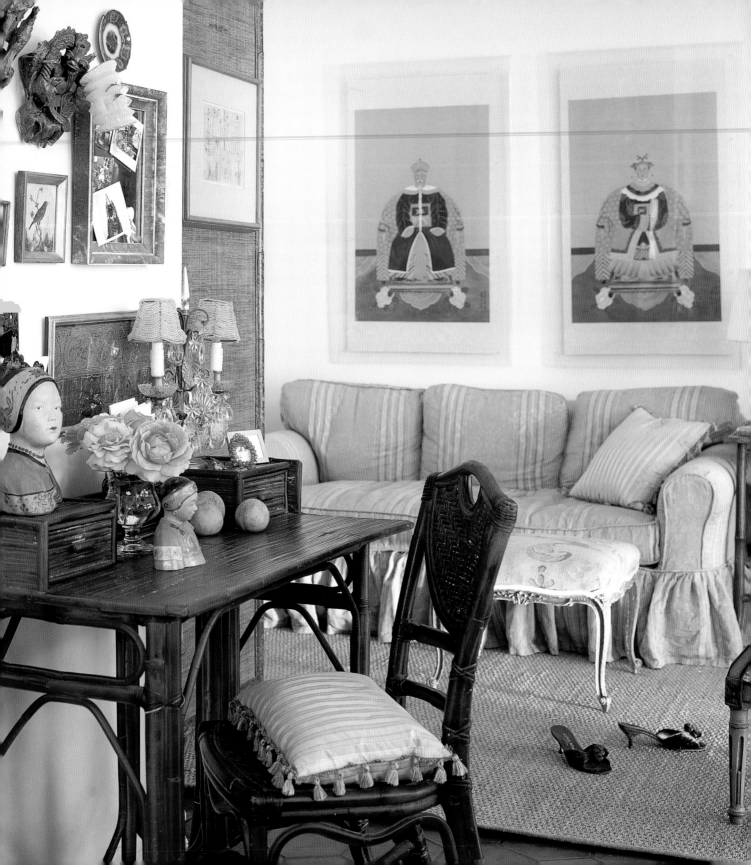

Ever since she can remember, Melissa Wallace Deitz has loved antiques. Even at 18, she was shopping for elaborate old French furniture and Empire chandeliers. ☿ Los Angeles is one of the great places for antiques. In California, there have always been connoisseurs, and the entertainment industry generates antiques both grand and humble. Movie and film-star tastes keep the finest antiques and pieces of questionable style and of unusual provenance in circulation. ☿ Deitz once found a 1920 Baccarat chandelier owned by Ava Gardner. And she works hard to find the best things for her design clients. But the lineage of objects she buys for herself can be uncertain, non-existent, or quite vague. She can be captivated by a carved coconut bowl with rock-crystal handles, elaborate old-world upholstery, vintage textiles, pressed glass, or an English baroque lead urn with chipped white paint. ☿ "I love antiques rather than new things because something old comes with a history," she said. "It plays with my imagination. Who owned it? Where did it come from? Who made it? Which houses has it lived in?" ☿ Perhaps it was inevitable that her passion for antiques would lead to her opening W Antiques and Excentricities on

Melrose Avenue in West Hollywood. There, Deitz—often helped by her mother—stocks a constantly changing array of eighteenth- and nineteenth-century furnishings, found on frequent forays to France and England and from her secret sources throughout Southern California. She also offers custom upholstery with vintage trim. ☿ At home in Hollywood in her 1922 Mediterranean-style house, Deitz and her husband, Geoffrey, and dogs, Max and Maud, enjoy an eclectic collection of furniture. "I love everything from art deco to chinoiserie of various eras to rococo," said Deitz. ☿ But unlike

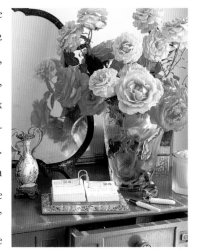

most antiques dealers, Deitz does not have a revolving door for the antiques in her house. "When I love things, I can't part with them," she admitted. "My furniture, my favorite old English garden urns, and my sofas are here to stay. The trick is to carefully edit everything that comes into my house. You don't want clutter to hide the objects of your affection."

OPPOSITE In her family room, Deitz hung Chinese ancestral portraits above a sofa with a striped cotton slipcover. The bamboo table, topped with plaster heads and carved wooden boxes, was waxed to give it the patina of age. The secret of her striped linen/cotton slipcover: Deitz has the Italian fabric washed at least five times before the slipcover is sewn. This fades the color a little and gives the textile a more relaxed look, and she knows the slipcover will never shrink. ABOVE In her Hollywood living room, Melissa Wallace Deitz goes on a gilt trip but keeps the decor relaxed and lighthearted. It's glamour—with go-go boots.

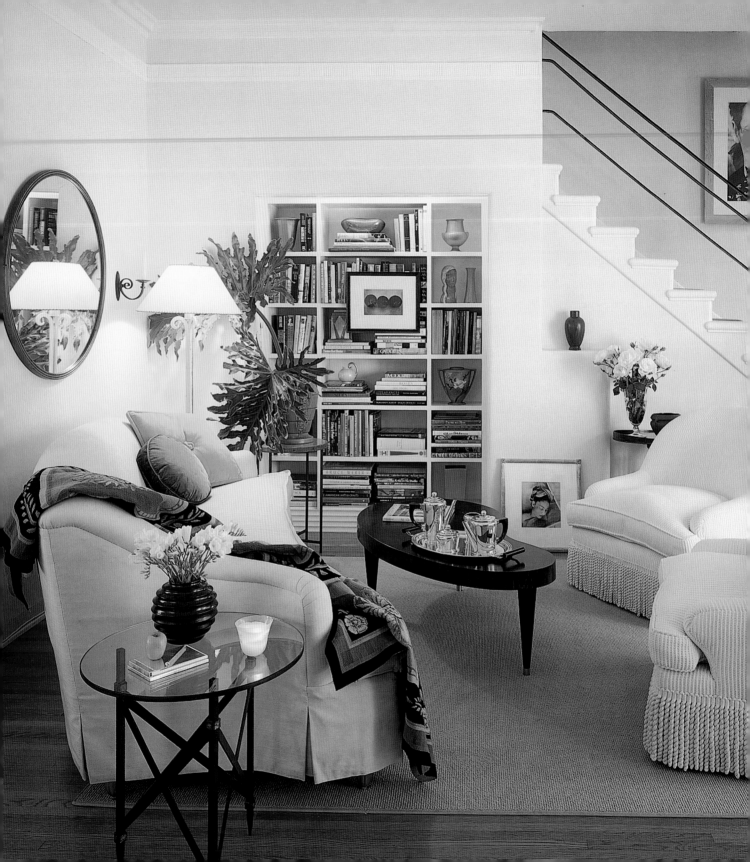

Writer Deborah Sroloff has the kind of apartment that is perfect for its south-of-Sunset-Boulevard neighborhood. It has graceful architecture, curvy upholstery, and the kind of mellow-mood colors that wrap the rooms in creamy comfort. ⚮ This refuge-from-the-madding-crowd has soothing fabrics, sensuous upholstery, and barely-there colors that robe the rooms in languor and ease. ⚮ Hollywood glamour with a low-key, modern, whisper-don't-yell sensibility is a style that young Los Angeles interior designer Michael Berman knows how to pull off. "It's important to keep glamour today grounded and never let it slide into theatricality," said Berman, who went searching for an apartment with his client, and came upon this treasure on a pretty tree-lined boulevard. ⚮ Trying to copy over-the-top old-Hollywood taste can too easily veer into parody. Designers do better to reject glitz and hyper-luxe and instead introduce less obtrusive luxuries, such as rich fabrics and finishes, deep-down comfort, and perfect proportions. That was Berman's approach. ⚮ "Debbie and I loved this apartment the moment we saw it," recalled Berman. "It's in a Streamline Moderne townhouse and has very sculptural mouldings, curved walls, and great, high ceilings. It felt chic and almost Parisian, yet still quite simple." ⚮ The designer selected oval-shaped armchairs and upholstered them in ribbed cotton chenille with thick bullion cord trim. The coffee table, from the fifties, has an ebony stain. Berman's curved "Lexington" sofa has a box-pleated "mini-skirt" and fluted, silver-leafed legs. ⚮ "We were looking for the luxury that traditional design can bestow, but planned to keep the mood very here-and-now," said Berman, who designs both interiors and a growing collection of furniture. "In all the rooms I design, I build one or two pieces that might seem a little kitschy in comparison to the decor's simple elegance. That offbeat addition builds personality and avoids any just-purchased feeling." ⚮ Berman added that the wish to avoid a "showroom" look in interiors leads him to more and more custom design with special finishes and unusual textiles. "We were scavengers for this living room, seeking prints and vases at swap meets. Books, vintage fabrics, shapely tables, odd-shaped pillows, and singular vases help avoid that 'whip 'n' chill' instantly formulated look that is death to design."

OPPOSITE Grace and charm: Michael Berman's updated classic upholstered furniture is particularly apt for this thirties apartment. The black steel-ribbon railing curves around a pair of chenille-upholstered armchairs. The Mondrian-esque bookcase is set into a niche in the wall. Berman's color palette runs the gamut from ivory to cream and ecru — with dashes of ebony and black lacquer.

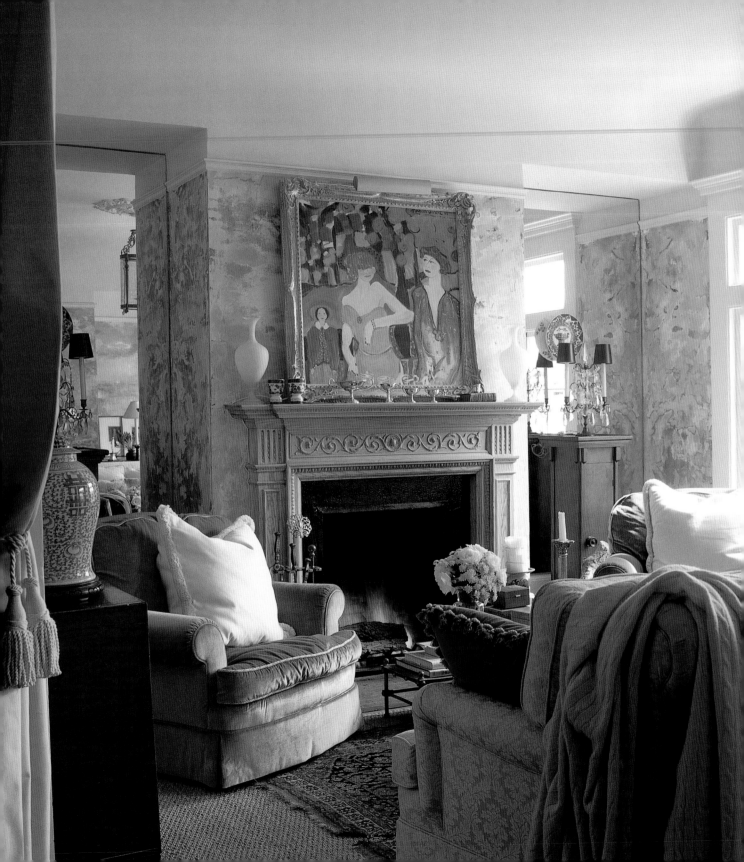

STEPHEN BRADY

A HOUSE IN
SAN FRANCISCO

Stephen Brady's two decades of interior design experience show in the offhand charm and confident style of his rooms. ⚥ Brady created the display for Britches store when it first burst on the scene in Georgetown, Washington, D.C., in the seventies. He later directed visual merchandising for Polo Ralph Lauren and for Calvin Klein in New York. He moved to San Francisco to direct visual merchandising for The Gap and Banana Republic. ⚥ All the while, Stephen Brady has experimented with interiors for his various residences — and has been in demand decorating for friends. He now has private clients and designs their rooms, poolhouses, beach houses, and weekend retreats with a consistent vision, authority, and firmly held opinions. ⚥ In his own San Francisco apartment, Brady often experiments with new color schemes, a change of mood. And so it was that one day he decided to change his living room after the walls were damaged by a winter storm. ⚥ In the process of having the wallpaper removed, Brady discovered the mottled celadon and chalky white tones of the walls underneath. "I loved the odd 'ruined' look of cracked and mottled plaster and the dusty green color that appeared," recalled Brady.

"I decided to take all of the wallpaper off and reveal variegated tones beneath." ⚥ Not every inch of revealed plaster was as scenic as the first, so Brady had a painted-finish artist even out the colors on all the walls and enhance the ancient look. ⚥ With the room looking somewhat more formal, Brady also changed his upholstery from cream damask to taupe velvet. ⚥ This style is the second incarnation of Stephen Brady's San Francisco living room. Formerly, the sunny room was monochromatic, with creamy-white walls, pale-ivory upholstery, and just an oil painting for a dash of

color. The oil, painted by Marion Vinot and purchased in Saint Barthelemy, hangs over the stripped-pine fireplace mantel. He also brought in two club chairs (made by Fitzgerald) and more vintage silver objects and silken pillows. The room is now mysteriously moody, day and night, and seems miles — and centuries — from present-day California.

OPPOSITE Mottled plaster walls are the only pattern in Stephen Brady's San Francisco living room.
An oil, painted by Marion Vinot, hanging over the fireplace is the one piece of vibrant color in the room. His aesthetic:
classic comfortable furniture, sensual textures, and muted colors. ABOVE Seasonal flowers arranged in
a cut-glass vase are a classic detail in this casually elegant setting.

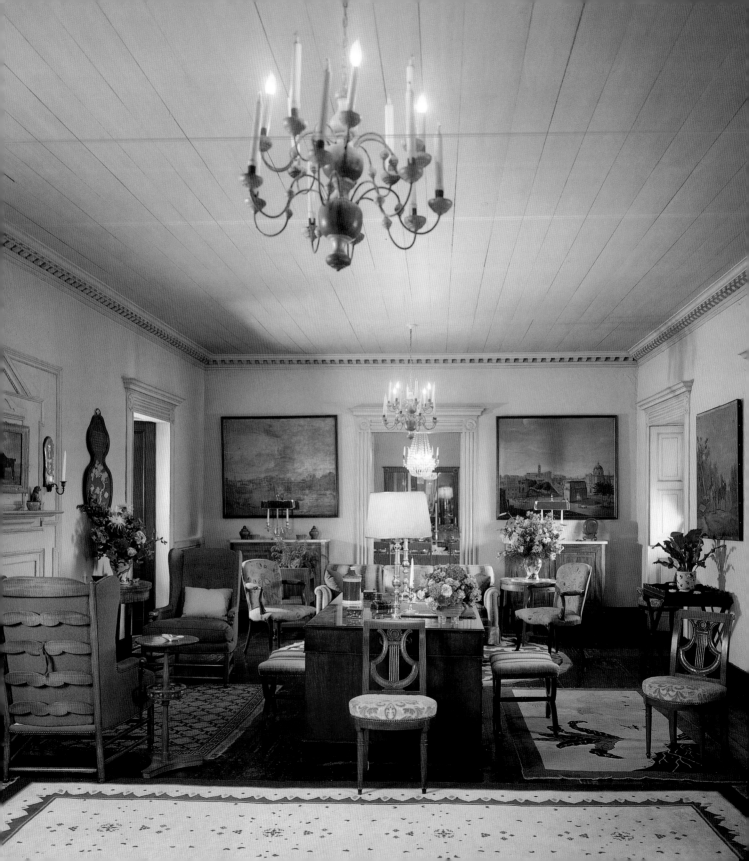

In conversations with today's top California interior designers, the name of decorator Frances Elkins (1888–1953) is very likely to surface. Thirties and forties films may have taken fantasy California decor into the world, but the most admired and influential early California designer was Frances Elkins. ☿ Today, Los Angeles designer Michael Smith is inspired by the many layers of design and style she combined. He appreciates the appropriateness of her decor and the relaxed sophistication of her rooms. ☿ Elkins, who grew up in Chicago and moved West in the twenties to set up shop, traveled to Paris each year. Her fine-tuned aesthetic sense immediately appreciated the crisply authoritative new styles of fashion trend-setter Coco Chanel and furniture designer Jean-Michel Frank, with whom she became friendly. ☿ Elkins had a particular fondness for chic European furniture, and later imported plaster shell lamps, Giacometti tables, Jean-Michel Frank twisted plaster floor lamps, and provincial French furniture, all of which became her signatures. In turn, these sculptural pieces became basics of San Francisco interior designer Michael Taylor. His bold vision was borrowed and adapted by his followers. White plaster lighting and Jean-Michel Frank tables, sconces, and upholstered chairs and sofas are now the most-copied items of today's design vocabulary. ☿ Fashioning proper period rooms was not of great interest to Frances Elkins. Her avoidance of design dogma and equally enthusiastic embrace of Moderne, Louis XVI, Art Deco, and French Provincial furniture were perhaps her greatest gift to generations of California decorators who followed. One-note design was out. Personal taste, experimentation, eclecticism, oddly beautiful colors, and risky combinations of fabric and materials were to be celebrated. ☿ In Elkins' footsteps, designers have been able to create a rather offhand, clean-lined effect that works well on the West Coast. Rather than a riot of pattern, she preferred coolly chic two-color schemes kept low-key with dashes of white and pale neutral colors. She wanted people to be comfortable in her rooms, not intimidated. ☿ At its best, Frances Elkins' design allowed Parisian salon furniture to coexist with unpretentious linens, well-proportioned upholstery, and graciously comfortable chairs. The exalted and the humble coexist in harmony. ☿ Frances Elkins' inspiration endures in the best California interiors.

OPPOSITE Since Frances Elkins' death, her historic 1830 Monterey adobe house, Casa Amesti, has been the headquarters of a social club. The living room and adjacent dining room are exactly as she left them, complete with her painted chairs, Venetian glasses, paintings, cachepots, quartz crystal lights, porcelains, cloisonné, and signature blue-and-white Chinese carpets. With her deft combination of unpretentious semi-antique furniture, simple sofas, inexpensive French prints framed formally to give them some artistic heft, and a pale blue/gray wash on the walls, Elkins forged a new California style.

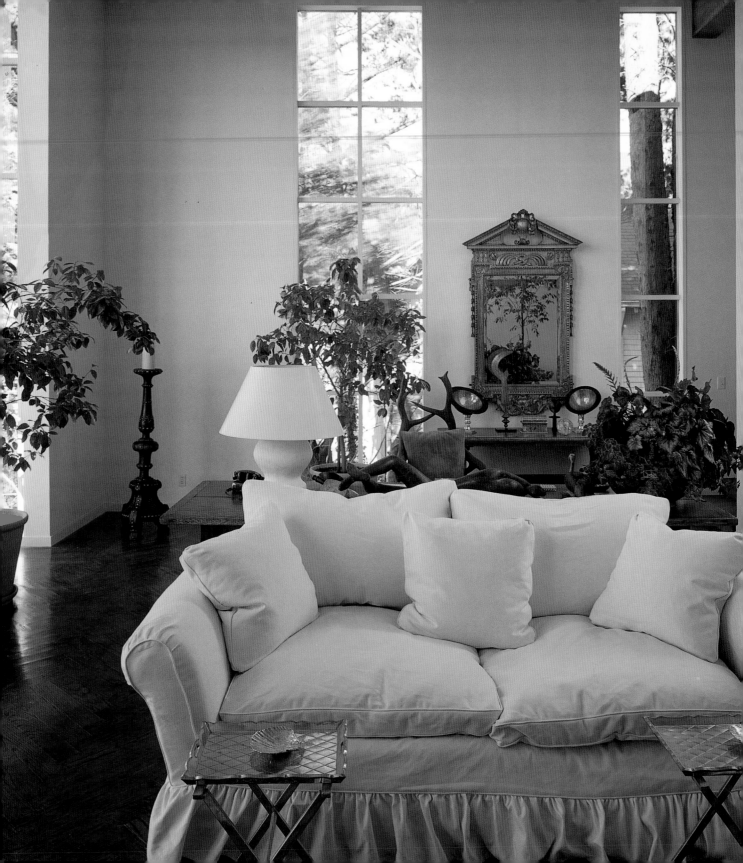

Among Michael Taylor's important design collaborations, one of his most successful and instructive is the living room of architect Sandy Walker's house in San Francisco. Walker's classic architecture—with banks of windows, shafts of light from skylights, and crisp lines—provided Michael Taylor with the ideal setting for his boldly scaled furniture. This living room measures 32 feet wide by 16 feet deep by 16 feet high. Taylor's romantic white-cotton upholstered sofa was designed in 1970, long before Indigo Seas and Shabby Chic made ruffled slipcovers popular. Elegantly, confidently, this sofa takes its place center-stage, like a beautifully dressed guest who came to stay. Taylor's contrapuntal choices give the great volume of the room both visual delight and decade-leaping individuality. In front of the voluptuous sofa stand, tip-toe, Indian handcrafted silver trays, both useful and decorative. A stone table, one of Taylor's own virtuoso designs, is surrounded by Mexican country stools, their seats a simple tracery. Taylor's talent for bold contrast is evident, too, in his placement of an antique gilt mirror. Its tall frame echoes the attenuated form of Walker's windows. This is California design and architecture at their best. Appropriate to the Bayside setting and comfortable with its contradictions, the interior looks as pertinent and appealing today as it did 27 years ago. "We still have that sofa, but it's now upholstered in tailored white canvas, and joined by a pair of Jean-Michel Frank chairs and a John Dickinson plaster tripod table," said Walker. "We move things about from time to time, and bring in new paintings or trees, but the original dynamics of the room are honored." The attenuated vertical proportions of the windows are reminiscent of French doors — bringing in the sky. The room feels like a French pavilion — inviting, dreamy, and somewhat open-ended in its design. Walker now has a banquette and coffee table where the dining table used to be. A baby grand stands in one corner of the living room, and looks very much in its place, not awkward and odd as pianos often do in contemporary rooms. "The floors are now glossier, the trees outside fuller, and the house still gives me a great deal of pleasure," commented Walker. "When you get design right the first time, you don't have to tinker with it much."

———

OPPOSITE Photographs of architect Sandy Walker's living room, taken by Fred Lyon in 1970, illustrate the timeless beauty of classic architecture and appropriate furnishings. Michael Taylor's take on California style: A massive sofa is poised center-stage, with attendant silver tray tables. Plants and trees bring the outdoors inside. Behind the sofa, a stone table designed by Michael Taylor is surrounded with movable, handcrafted Mexican stools to become an all-purpose gathering spot for dining, reading, and working.

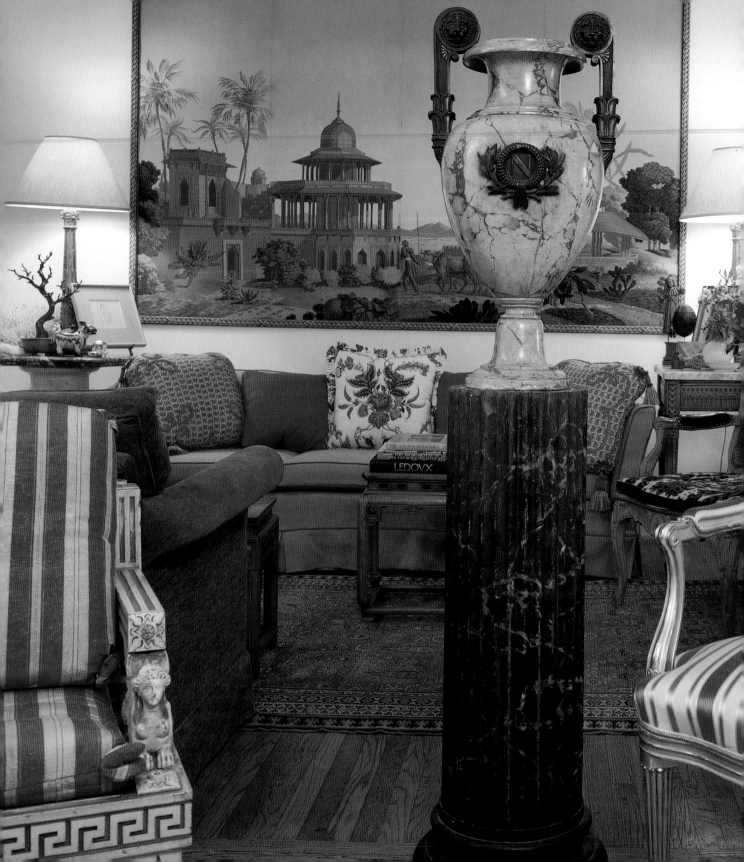

Antiques dealer Robert Domergue has a fine sense of drama. At his Jackson Square antiques gallery—a favorite with California's discerning collectors—he displays a broad range of both illustrious and recherché pieces. He appreciates painted furniture, surreal sculptures, certain naive carved furniture, Biedermeier furniture, "Grand Tour" *objets*, English Regency, early neoclassical French and Danish furniture, early Empire decor, and objects with spirit. Still, even in this broad range, each object seems important, every one is given its due. ⚲ At home in Pacific Heights, his style is more focused. "I keep only pieces I love and wish to see every day," he said. "I believe that if you buy antiques because you 'should' and put them in a room, it looks like a stage set." ⚲ For Domergue, the key is to select favored pieces that are linked together by a common thread or a theme, then to edit them. "If you have a defined taste, your personal style can inform and unite your furniture and painting selections even when they are all over the map," said Domergue. ⚲ The Domergues rose to the challenge of giving their Victorian jewel-box house an infusion of style. The living room was 25 feet square, but it had no fireplace. After intermittent renovations by previous owners, few architectural details remained. The antiques would have to do all the work. ⚲ "When you have a distinct, consistent point of view, a room tends to fall into place," said Robert. "I always liked the arts of eighteenth-century France, so I brought in my Louis XV carved chair, the sphinx carved chairs, French chaises longues." ⚲ Details count in this Domergue domain. The rose and gray tones of the paisley pattern in the Caucasian village carpet inspired the gray velvet upholstery piped in rose red. The Greek key carved

chair with its broad stripes sits near an imposing Napoleonic urn, and its urbane, silk-stripe upholstered French companion. The printed paper panel is Portuguese. On a Tuscan table and a column table are small and choice antiques. The Domergues have created an image of opulence and pleasure in a Victorian parlor — and triumphed over minimal architecture.

OPPOSITE Robert and Elizabeth Domergue's living room seems somewhat sedate — but rich, regal ruby red adds considerable glamour. The First Empire scagliola urn, *circa* 1810, may have been commissioned for the offices of Napoleon. The block-printed wallpaper is by Zuber. Velvet upholstery colors of the armchair and sofa were deliberately muted to play second fiddle to the Domergue family's fine collections. ABOVE On a three-legged Tuscan table are displayed an eighteenth-century gilt bronze lamp, originally used to illuminate a parlor game. The painting on paper is Portuguese. The trompe l'oeil faience dish of "olives" is eighteenth-century French.

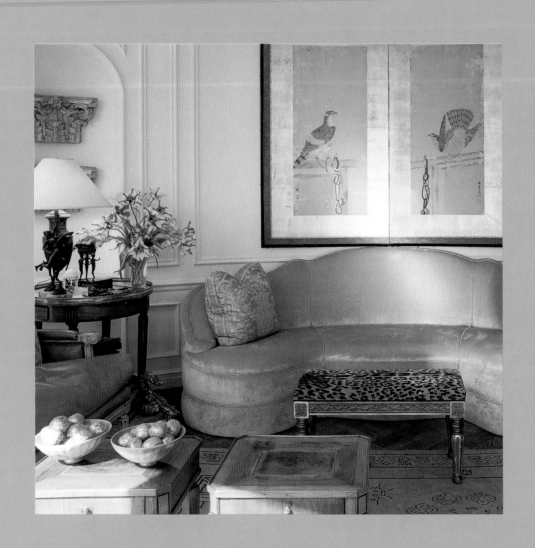

DESIGN WORKBOOK

Design ideas are all very fine, but how are the best design decisions made and focused rooms created? How can you free your ideas from the tyranny of what's "right" and start on a journey to finding your own style? How do you get the courage of your convictions and move beyond mere furnishing to true design? California's best designers, offering years of experience in a broad range of interiors, have straightforward and unexpected suggestions for solving the conundrums of decor. Far from dictating and teaching outmoded "rules," they guide you through everyday problems. Best of all, they offer new ways of looking at furniture selection. Educate your eye, they say, by reading design books and magazines, and visiting design stores and showrooms. Keep your mind open. These designers are very opinionated, and their wisdom is passionate, practical, and profound.

OPPOSITE Syrie Maugham–style sofa in designer Paul Wiseman's Nob Hill apartment.

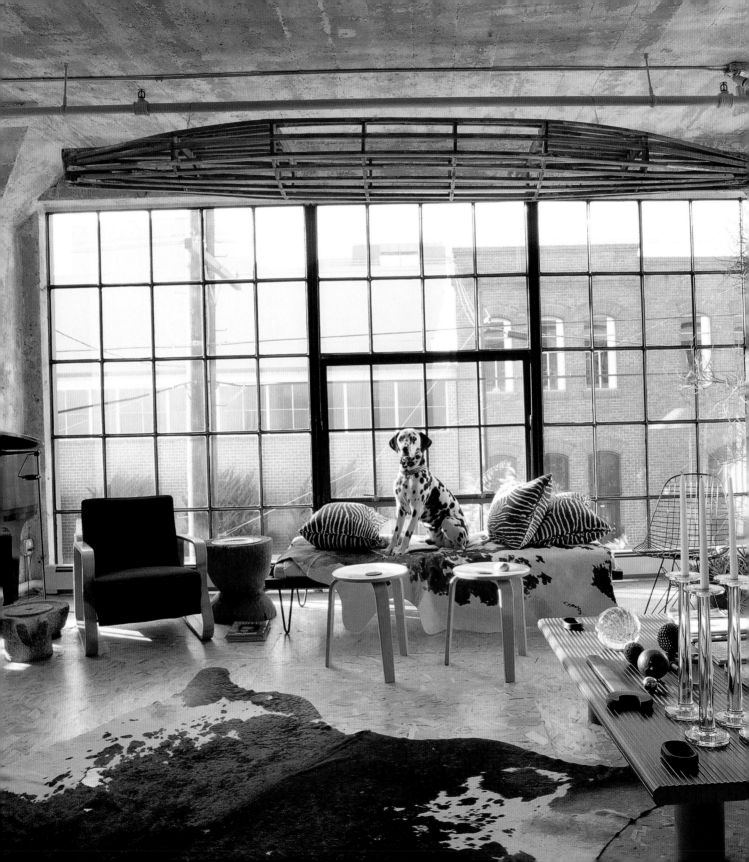

ECLECTIC DESIGN

Take a brave leap into more personal decor. Throw away the old idea that everything has to "go together" or "match."

Just as in fashion it's chic to wear a Gap T-shirt with a Chanel jacket, a Gucci belt with a Banana Republic skirt, an Hermes silk scarf with Levis, Jil Sander teamed with Fruit of the Loom, or a vintage cashmere cardigan from a thrift store with Armani tailored wool pants, so a more impromptu approach to decor can enliven a city apartment or a suburban house.

Theme decor — any scheme you can instantly label—is no longer the goal of interior design. Combinations like eighteenth- and nineteenth-century architectural detailing in a very pared-down modernist house show off the best features of them all. Juxtaposing thrift-shop finds and family heirlooms, or a romantic gilded Venetian chair with a very linear table with straight metal legs gives a room life and personality. Eclectic design gives great design freedom, and it's perfect for those furnishing on a small budget, since serendipitous charity-store finds bring new energy to bland rooms. All you need is the courage of your convictions.

If your auction chairs or sidewalk-sale vases don't match, it's not a calamity. A chair or lamp that's a bit "off-key" in scale or color can make the whole room sing.

Eclectic design is more versatile, less limiting. When you're ready to change a table or move in a new style direction, the scheme won't collapse.

Contemporary paintings and antiques make a fine combination. A funky old metal chair in a living room will contrast well with "proper" pillows of embossed silk. A very architectural metal lamp adds intriguing geometrical lines to a traditional room,

standing on an antique-looking hand-hewn oak. An idiosyncratic collection of pottery, art glass, or handmade bamboo baskets averts the overly controlled cookie-cutter look in a room.

"A room will always look more interesting if you bring together something very old with some-

thing very new," Tiburon interior designer Ruth Livingston advises. "Don't feel constrained to have each piece matching in period or style. Refurbished old occasional chairs and a coffee table from your attic or a charity shop would enrich a living room with a new sofa. When everything in a room is brand new it cries out for furniture or accessories with some history, texture, and signs of age, otherwise your house will feel like a hotel."

In his modernist apartment, San Francisco interior designer Gary Hutton likes to combine modern classic white plaster tables by John Dickinson with thirties chrome chairs, a Biedermeier chest, California

ABOVE & OPPOSITE A loft offers carte blanche for eclectic decor. When San Francisco designer Jonathan Straley found his South of Market loft, it was bare-bones all the way. Now the concrete box is entirely his own after adding a new particleboard floor, a bold center column for art, and fifties furniture. His taste is far-ranging — from Noguchi to Eames and Aalto, plus flea market swaps, contemporary art, and in the ceiling, the skeleton of an old skiff.

plein-air paintings, and large-scale contemporary paintings. The effect is personal, provocative, and pleasing. His rooms change and become richer as new collections and finds are added.

"Designing an eclectic room does not really mean that anything goes," said Hutton. "Dashing a room together with little thought for the finished effect would result in a confused hodge-podge of furniture and collections. Clutter is confusing. You must exercise control. The concept that holds furnishings of a room together may be fine craftsmanship, country of origin, design integrity, color, or design period."

No one will be censored by the design police for combining vintage Sheraton-style mahogany dining chairs with a sleek contemporary table, or surrounding an ornate Florentine gilded mirror with black-

and-white photographs bordered with chaste white or black frames.

San Francisco designer Orlando Diaz-Azcuy likes to contrast refined linens and silks and chairs with rustic galvanized metals, well-worn baskets and primitive textiles. He also likes to have unexpected combinations in a room to make it truly individual.

"I like the idea of showing one or two pieces of avant-garde design in a somewhat sedate room," said Diaz-Azcuy. "Our generation is exposed to suave Italian furniture and sleek Scandinavian pieces, along with newly crafted furniture. All can exist together happily if they're good quality and have inherently good lines."

In his own dining room, Diaz-Azcuy counterbalanced an elegant carved Venetian settee upholstered

GETTING IT RIGHT

Design and decorate rooms to please your own taste, your life, and provide comfort and pleasure for you and your family. Things you love and like to use tend to come together harmoniously.

Everything in a formal room does not have to be expensive, authentic, uptight, or traditional. Juxtapose mementos, beach treasures, children's paintings or contemporary crafts with antique accessories and classic furniture.

Curvy fifties chrome and leather furniture makes the perfect contrast with kilim rugs, overstuffed

damask-covered armchairs, and serious Arts & Crafts furniture.

Non-figurative paintings, prints, and black-and-white photography in simple gold or plain wood frames bring a breath of fresh air to rooms furnished with mahogany or dark wood tables and chairs. Take a somewhat loose, relaxed approach to hanging your photography or drawings. Make them look as if they have appeared randomly over years. Prop some on shelves, others on a mantel.

Take a more informal approach to textiles. Colors should not be exact

matches — nor look as if everything came out of the same pattern book. Mix fabric patterns with confidence. A graphic and colorful quilt, a boldly designed or hand-painted pillow, or art deco–style upholstery fabrics can infuse a sedate room with the element of surprise.

Think of decor as flexible, changeable, and movable rather than cast in stone. The best rooms evolve over time, with new chairs, family craft projects and paintings, antique tables, and a variety of family photographs bringing new life and style.

If your eclectic decor looks like too many odds and ends and furniture placement is difficult, consider heavy editing, or bring in a professional designer. Often with one consultation, a decorator can bring out the best in a room, rearrange the pieces, and create a fresh and more pleasing decor.

To give a living room a more contemporary edge, combine contemporary sculpture with vintage American and heirloom furniture.

OPPOSITE Chuck and Jean Thompson mix paintings and folk art from Mexico with a silvered modern table and a forties slip-covered sofa.

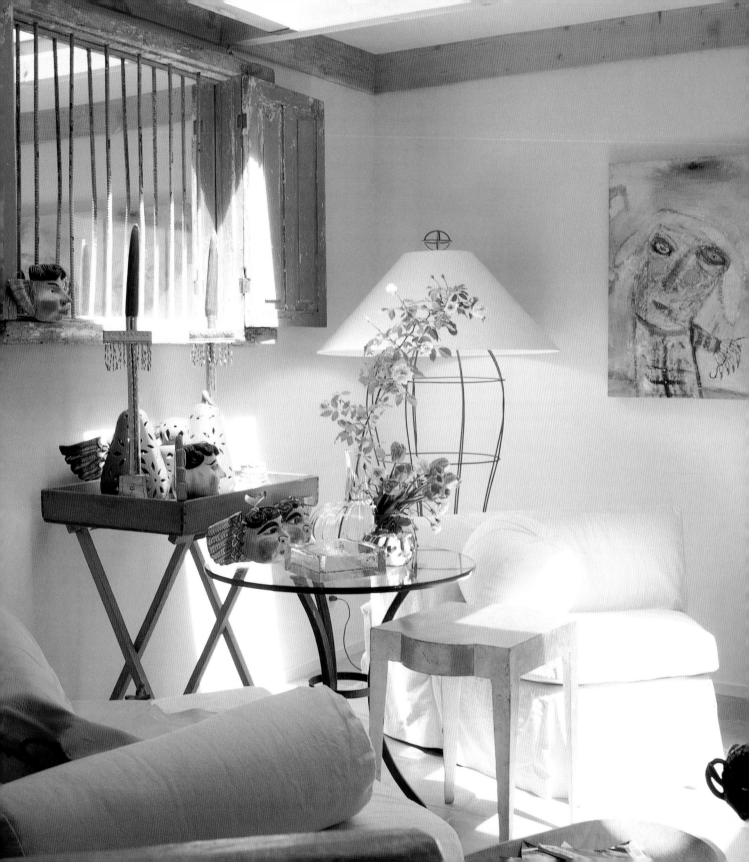

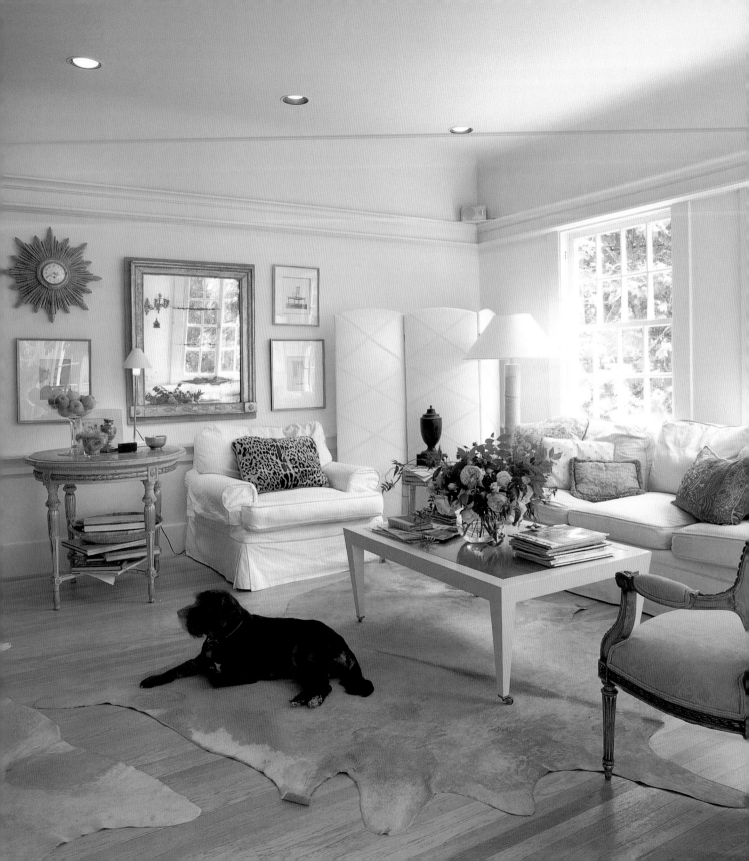

in understated white linen with an exotic gilded Viennese chandelier. Beneath a rather grand neoclassical dining table, he has set a simple wool/sisal rug.

Breaking Design Rules

Design rules—those incredibly restrictive ideas about what has to go with what—have gone the way of the dodo bird.

Berkeley interior designer Stephen Shubel said that if you fear going too far with your style mixing, start with a somewhat monochromatic or neutral color scheme, as he did in his own apartment, and furnish slowly. Add paintings, patterned fabrics, pillows, vases, antiques, and textured carpets as you go along. Don't aim for instant decor.

"If you first establish a mood, a style or an attitude, you can build your style carefully and confidently from that," said Shubel. "Eclectic design does not mean that you throw a room together with no thought. You need a thread that unifies the decor. Decide that your room will have a country or rustic feeling, a romantic mood or a very Zen simplicity, and plan to give that look your own non-clichéd interpretation. The starting point could also be a favorite color, a design period you love, family heirlooms, or handcrafted furniture."

In his own chic, informal living room in the Berkeley Hills, Shubel achieved an eclectic style with a light touch. White fabrics and chalky white paint embellished with gold ornamentation are the unifying touches.

"Eclectic does not mean cluttered," said Shubel. "If you have too many objects or too much pattern, the decor can feel restless, spotty, and unfocused. Consider having just a few wonderful things of the best quality rather than many mediocre things."

Shubel sets the stage in his living room with white-denim-upholstered armchairs and a comfortable classic sofa, also covered in washable white denim. (He has two dogs.) His contemporary Donghia coffee table is whitewashed and has a silver-leaf top.

Beside the sofa stands a pair of ornate antique gilded Italian chairs upholstered in white canvas. Their curves and ornate carving show well against the pristine white fabrics. On the white mantel, he displays framed French furniture drawings, white marble architectural fragments, gold-leafed old candlesticks, and other gilded finds from Paris flea markets.

And what are the fainthearted to do about eclectic decor and developing personal style? Perhaps the best approach would be to start by changing an existing room. Something old — from a top antique store, an antiques collective, or a sidewalk sale — can always improve a room. Give something shiny and new a painted finish. Search in the attic for vintage fabrics, neglected books, old family albums and portraits to add a sense of continuity and history to new rooms. And above all, explore new design concepts such as contrast, counterpoint, juxtaposition, and surprise. Rooms should never be too complacent.

ABOVE & OPPOSITE Stephen Shubel fashions a harmonious impression with an international mix of furniture and accessories. Pale colors and pared-down furnishings create a pleasing atmosphere. Selecting a classic sofa, Shubel adds the counterpoint of a new silvery coffee table, a bamboo lamp, armfuls of lavish roses. Note the perky new lamp on the gilded French marble-topped table.

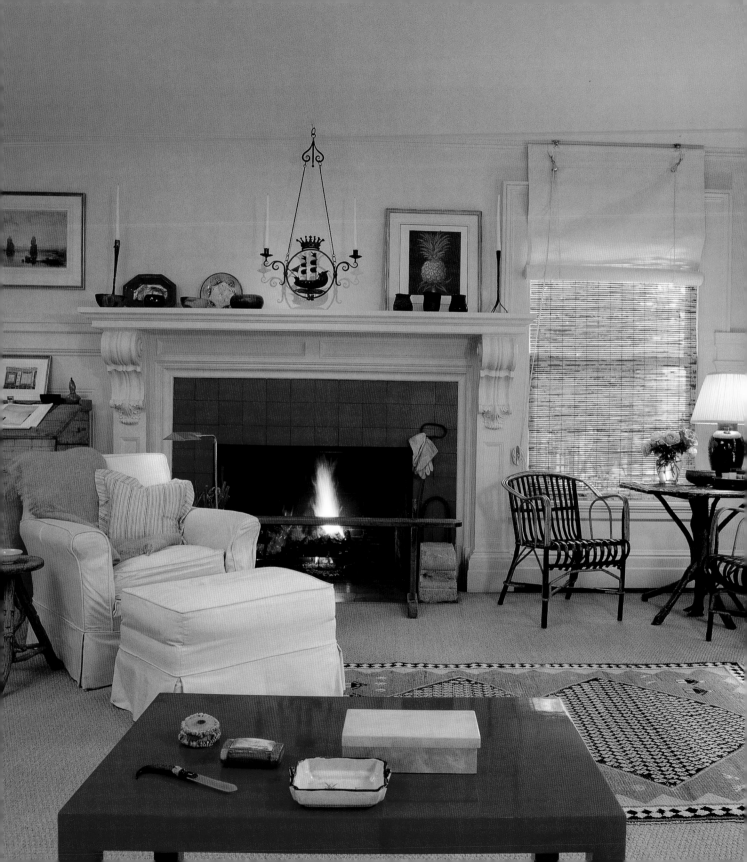

SMALL ROOMS, BIG IDEAS

Rethink scale and proportion for small rooms. Consider comfort and style. Just don't think small.

To challenge interior designers' ingenuity, give them a small room to decorate. With no room for error, they have to be inventive and very nimble.

San Francisco interior designer Michael Tedrick, at six-feet-four-inches tall, understands only too well the problems of small rooms. He moved into a handsome one-bedroom apartment in a former embassy in Pacific Heights. Dimensions: just 400 square feet.

"Well-planned, a small one-bedroom apartment can be satisfying, comfortable, and very versatile," said Tedrick. "Confidently executed small rooms can be extremely inviting." Editing is a must.

Tedrick works and entertains in an elegant city apartment, circa 1890, he shares with his corgi, Wallis.

Tedrick relishes the placement and planning a studio apartment demands. "With one large room, everything is visible and obvious," said Tedrick. "Every piece of furniture, every lamp, every table has to be considered. Correct proportions are crucial." His apartment, designed as a gentleman's pied-à-terre, includes a six-foot-by-ten-foot sleeping alcove at one side of the living room.

Tedrick insists that everything be of good quality — though not necessarily costly. His understated sofa and armchair are both upholstered in oyster-colored silk velvet. To complete the grouping, he chose an eighteenth-century French antique leather wing chair.

The sofa is long enough to stretch out on, so that the apartment does not cramp his style. The coffee table is lacquered a deep oxblood red. It's topped with books, shells, a candlestick. In a well-lit corner of the living room, Tedrick has set a bistro table accompanied by a pair of rattan armchairs.

"When I entertain, or invite three for dinner, I bring in a pair of folding cane chairs. I pull the table away from the corner. There's plenty of room for all of us," he said.

In front of the fireplace, the designer arranged a single classic armchair in silk velvet (sometimes slip-covered in natural canvas) with a matching ottoman. His television set, on a metal rolling cart, is always stored out of the way in a walk-in closet.

"Rolling carts are a blessing for small apartments," said Tedrick. "Televisions and VCRs and sound equipment are best kept out of sight from day to day. They tend to take over the room and become too much of a focus."

Tedrick noted that a small room requires self-knowledge, motivation, and discipline. It is no place for the slovenly. "You have to be tidy and organized," he said. "I have little storage, so anything I introduce to these rooms is immediately in full view."

And small rooms do not have to feel stingy or tightfisted or lacking in comfort. Tedrick's silk velvet–upholstered chairs and sofa (with cotton canvas slipcovers for summer) are subtle to the eye and beautifully tactile to the touch. Everywhere there is something beautiful—often petite—to give pleasure, possibly to pick up for inspection.

OPPOSITE San Francisco interior designer Michael Tedrick's city studio apartment is big on style. His choice: an elegant monochromatic color scheme and carefully selected treasures.

Polished hardwood floors are an instant room picker-upper. For some rooms, lightening or stenciling the floor will freshen up the decor. For others, a handsome ebony floor finish will bring a crisp delineation. Sisal and coir mats work well for relaxed rooms.

A small room can serve many purposes. Choose a multi-use table that can be used as a desk, a dining table, or console table. Set up furniture arrangements that are not static.

Choose bold vases, large candlesticks, and generous bowls of shells or stones, rather than clutter the room with scores of tiny, meaningless objects.

A large framed, beveled mirror will double the apparent size of a room. An old mirror is usually more interesting than a new one. Hang it above a mantel, or stand a full-length mirror against a wall.

Well-thought-out small rooms should have "rooms" within the room. Plan several different seating plans so that everything doesn't revolve around the sofa or coffee table.

Softening the edges of a room disguises minuscule dimensions.

Use soft lighting, framed photographs, built-in shelves, voluminous draperies, or subtle wall colors.

Slipcovers on chairs and sofas help a small room feel more relaxed and give a sense of welcome.

Clear the decks. Take lamps, bookshelves up off the floor for a less cluttered look.

While fabrics in bold hues can bring character and individuality to tiny rooms, monochromatic taupes, ivories, and whites can be bliss in some small salons. There are no rules — trust your eye. While sun-struck Provençal colors may enliven some rooms, elegant, pale geometrics will work better for others.

Think about adding architectural interest to a nondescript small room. Crown moldings, wainscot, or a chair railing, a new fireplace or mantel, more emphatic window frames, or a handsome new doorway will give the room texture and dimension.

ABOVE Sandy Walker's chic study — Michael Taylor's stone table, movable Mexican stools.

OPPOSITE Patrick Wade and David DeMattei's small study: comfort, color, and ease.

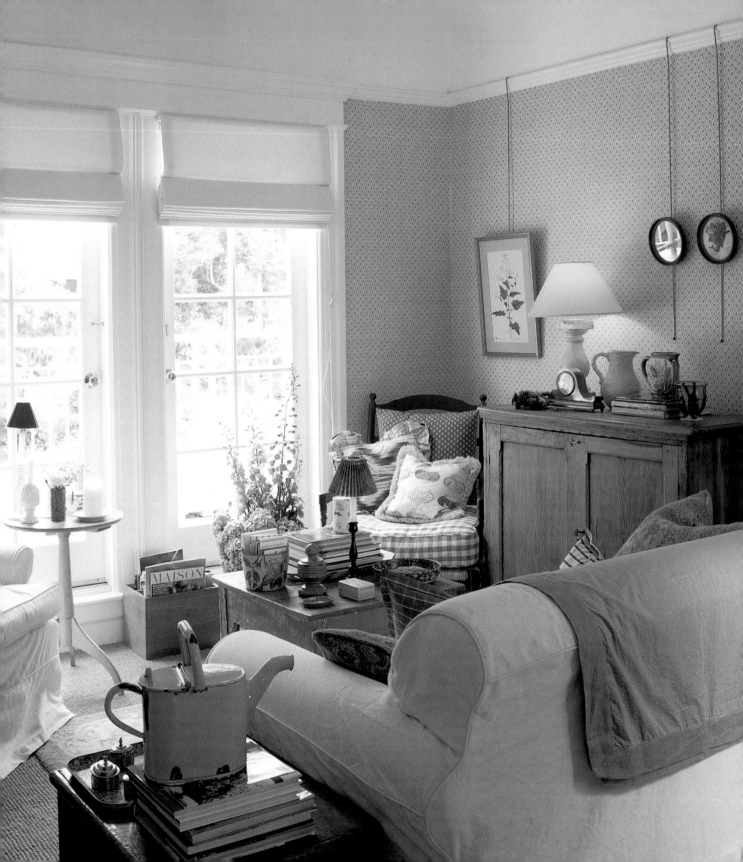

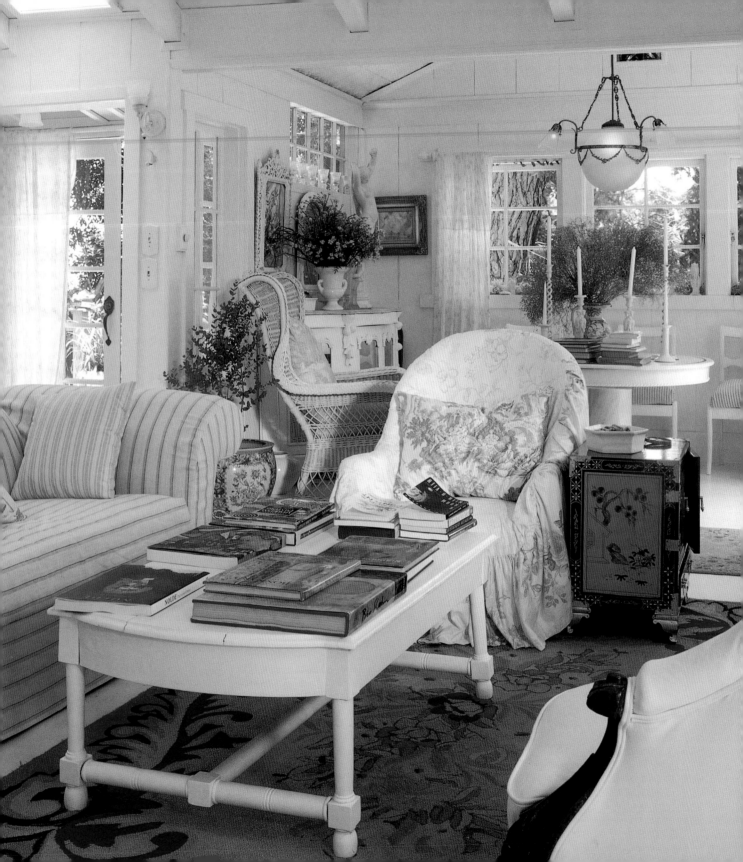

FLEA MARKETS

**California's favorite pastime. Stalk and shop with conviction and passion —
and learn from the experts how to use frugal finds.**

Frugal shoppers in search of affordable antiques and inexpensive vintage furniture are heading for charity secondhand shops, antiques collectives, thrift shops, flea markets, garage sales, junk shops, auctions, and sidewalk sales. Buying elegant twenties dining chairs to repair, faded old armchairs in need of upholstery, and handsome mahogany tables that have seen better days is one way to save money without sacrificing style.

The point of going to a flea market rather than a discount store is to find furniture with an interesting history and lamps and decorative accessories that will get more interesting over time.

Serendipity is an added attraction. You may have a chance encounter with a $200 treasure-in-the-rough—or fall in love with a $5 amateur portrait that becomes a friend for life.

A flea-market chair or candlestick with a few signs of wear won't have to be treated like a precious object. It can be used and enjoyed without worrying about nicking the paint.

Repainting and fixing chairs, repairing a worn-out sofa, or learning how to strip an unattractive paint job can be a rewarding weekend project. Restoring a set of mismatched flea-market dining chairs found for $20 is a challenging task that may take weeks, but the completed chairs will give pleasure for years.

Informed Purchases

There's great romance and adventure to swooping down on flea markets at dawn. It's important to remember that the bent $9 art deco lamp or $25 slightly cracked ivory-inlaid coffee table is purchased "as is." It's not like buying at a store. There are no guarantees. It may be the bargain of the century—it may not.

You can get real deals at junk shops, but it's important to make an informed purchase. The $15 bargain chair that has to be completely recaned or reupholstered will have new style, but you have to pay for labor and materials. They aren't cheap. A charming old roll-arm sofa you discover for $100 at a tag sale may start out thrifty. If it has to be resprung, recovered, and restored, it could cost $600 or more.

Reupholstering a bottomed-out chair may cost from $300 to $500 for labor, plus $300 or more for fabrics. To recover the seat of a dining chair may cost $50, plus perhaps $10 or $20 for half a yard of plain fabric, according to San Francisco upholsterer Lauren Berger.

"If you have to spend a lot for upholstery repairs, it's wise to search for unique old chairs or sofas with beautiful woodwork or a style that could not be duplicated today," advised Berger, an accomplished flea-market shopper. "Otherwise, you might as well buy a new sofa or chair."

Berger recently purchased a pair of handsome Louis XVI-style chairs for $10 each at a Valencia Street sidewalk sale. "Check an old chair frame and legs to be sure they are sturdy and the wood is undamaged,"

OPPOSITE Costume designer/painter Theadora Van Runkle can detect the most promising pieces among the horrors of small-town junk shops, Portobello Road booths, Paris flea markets, and Los Angeles weekend "antiques" shows.

said Berger. "Sit on the chair. Inspect the wood to be sure it is sound. Turn an upholstered chair over to see if the springs are secure. Cover fabric can be replaced, but a good frame is essential."

Berger suggested checking for mildew, water damage, and termites, all traps for unwary enthusiasts. Prod pillows, lift dust ruffles, and give chairs a thorough inspection. "Feather and down sofa and chair pillow fills can often be salvaged and refilled, but foam almost always has to be replaced."

Berger also recommends new slipcovers to bring a fresh look to a tired-looking junk-shop chair or sofa. "For around $150 for labor, a simple cotton slipcover gives an old chair an updated look without the expense of upholstery," said Berger.

Junking for Chairs

Top San Francisco painted-finish artist Lesley Ruda also goes "junking" in search of inexpensive old tables, chairs, and cabinets that she can paint and revive.

With her practiced eye, she seeks out small tables with unusual legs, cabinets with pleasing contours, and cheap chairs with unusual details that would be expensive or impossible to find in a new piece.

"I always look for underpriced pieces with potential that can be transformed with imaginative restyling," said Ruda, who teaches painted-finish classes at Paint Magic on Fillmore Street in San Francisco.

She recently bought two bentwood chairs with chipped green paint for $10. With a smooth new coat of gray-blue lacquer and painted calla lilies on the seat, the finished effect is priceless and very personal.

Painted-finish artists may charge from $50 to give an elegant finish to a picture frame, to $200 or more to give an antique chair a special new finish. To commission an elaborate tabletop design on a vintage piece or handpainted custom-design for an old cabinet might cost from $500 to $900.

Ruda, who trained in London, said that junk-shop furniture is often hidden under years of dust. "Don't be discouraged by a flea-market table painted a hideous color or by dirt or signs of wear," she said. "Simply clean it off, wash it, and sandpaper it to give a good surface for new paint."

San Francisco artist Michael Dute loves eccentricity, but suggested that beginners avoid vintage junk-shop furniture that's trendy, over-designed, or fussy.

"Simple, clean, well-made design is best," said Dute. "Be willing to accept a chair's flaws or a table's strange proportion if it's cheap."

ABOVE Designer Gary Hutton shows auction finds.

OPPOSITE Alice Erb has a practiced eye for finding treasures, even in the most unpromising antiques shops, flea markets, and junk shops. Among her favorite finds are chairs, tables, baskets, a sofa, and textiles.

SCOUT AROUND Check newspapers for traveling or special antiques fairs, church bazaars, and garage sales.

EARLY BIRD Set your alarm. Get there early for the best selections. Experienced foragers state that if you get to a flea market after 9 a.m., antiques dealers will already have raided the best furniture. As soon as you arrive, scan the scene so that you can avoid poor-quality booths.

MEASURE To avoid mistakes, take measurements for the tables, chairs, picture frames, and lamps you need. Sometimes it's difficult to judge proportions of a bookshelf or lamp on the sidewalk. It's disappointing to get a table home and find it's too big for the room, or to discover that a dresser won't fit between two doors.

NEGOTIATE When it's time to haggle, be friendly rather than aggressive or too eager. Some good-deal hunters say that if you go late, just before closing, you can negotiate good prices for what's left.

PLAN AHEAD Know exactly what you want. Focus on photography, chairs, vases, frames, a new coffee table, for example, so that you're not just wandering aimlessly. Be prepared for serendipity.

SEARCH At garage sales and estate sales, look under tables, in drawers, and on shelves for old books, silver, vintage fabrics, pictures, and treasures others have overlooked.

TRANSPORTATION You'll have to transport your new chair, table, or sofa home. Bring a friend with a pickup truck. Remember that if you have to pay freight charges, your super-cheap find may not be such a bargain.

EVALUATE Try to assess your purchase with cold, calm common sense. Buying at a thrift store, charity store, junk shop, flea market, or sidewalk sale has its own logic. You buy as-is. You can't exchange, generally. You cannot return your "treasure" if it's too big or turns out to have dry rot or an infestation of beetles.

PURCHASE If the flea-market gods are smiling upon you, and you come upon a well-made mirror, sofa, pitcher, or chair you love, it's in good shape, the price is right, and it fits your plan and measurements exactly, buy it on the spot. Most vintage finds are unique. They won't be there later.

APPRECIATE And don't ignore estate sales and auctions of less-exalted goods. Someone else's castoffs can become your treasure.

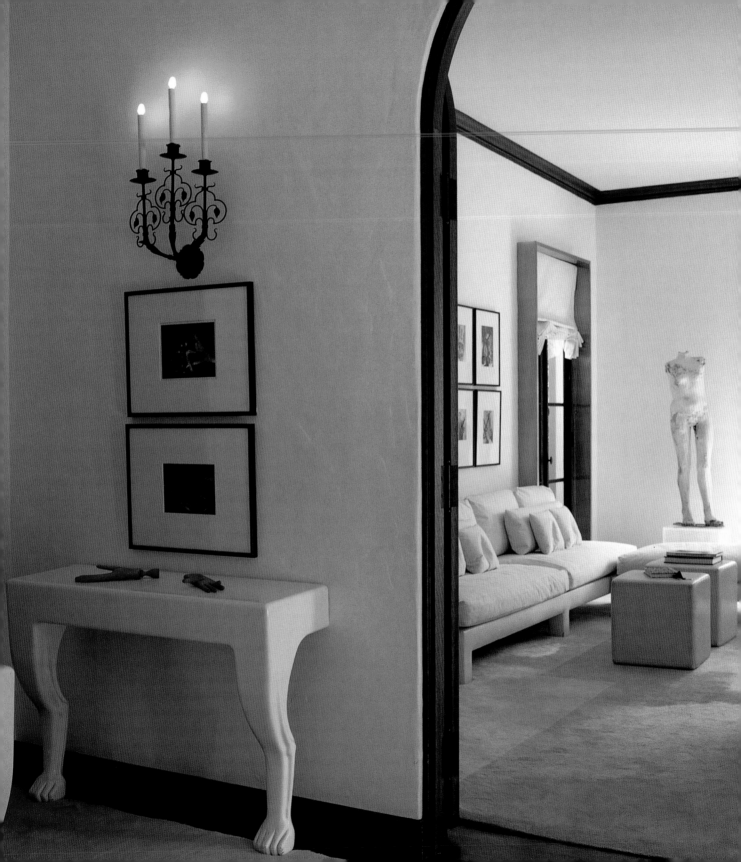

DESIGN INSPIRATION FROM JOHN DICKINSON

San Francisco designer John Dickinson, one of the most admired designers of the last twenty years, has strong opinions on matters of design.

∽ Taste is a word I avoid. Good or bad, it's all so nebulous. The more you're dealing with taste, the more you're on shaky ground. Vulgarity to me is another matter. Vulgarity has great vitality.

∽ Cheap pants, darling, always cheap pants. In fashion and interior design, it's not all deluxe. Tacky and mundane things liven up good design.

∽ I never use plants as part of design. And above all, no orchids. They have become such a cliché. If I wanted the profile, the looseness, the shadow that a tall plant would give, then I'd take tin and make a stylized imitation plant. That, you see, becomes design, rather than just a visit to your local florist.

∽ There's no cop-out in using pairs of things in a room. Matching chairs, sofas, lamps, or tables can bring discipline, strength, and balance to a scheme.

∽ The Regency or Egyptian influence was not in my mind when I first designed chairs and tables with animal feet. I was after something fetishy and quite surprising. The mock-primitive thing — the artificially primitive thing—is quite marvelous and it hadn't been explored at all. Designers usually have gone the other way, taking something primitive and refining it beyond recognition, usually ending up with something banal. If you go the other way, as I did, you usually end up with something very peculiar looking but something quite successful.

∽ You cannot do a lasting room design based on a current fad or novelty.

∽ The reason I can't use strong color with conviction is that it draws attention away from aspects of design that involve line, proportion, and shape. A color scheme is a questionable device on which to base a room design.

∽ There are many places in a house that do not warrant expensive furnishings. It's really not essential to spend everywhere. Muslin curtains can be the prettiest things in the world if they're sewn beautifully. You just don't have to make a big production of everything in a room.

∽ Some of the easiest things to use as inexpensive accessories are natural objects. Seashells are heaven. The bigger the better. Coral's marvelous if you can get big pieces of it. Little pieces don't mean anything.

∽ I'm always embarrassed by relentless collections. Often people are collecting things because they're told that it's very chic and "cultured," and that it gives meaning to their rooms. As a matter of fact, a mundane or hackneyed collection usually robs them of any meaning.

∽ I don't like prints on fabrics or wallpaper, period. My theory is that prints are unnecessary because if you have an attractive room in solid colors the whole room becomes the pattern.

OPPOSITE In Dr. Leo and Marlys Keoshian's Palo Alto house, John Dickinson honored the architecture with rather spare furnishing. The sofa and chairs are covered with cotton canvas. Paled-down colors, no pattern, and understatement guarantee design longevity.

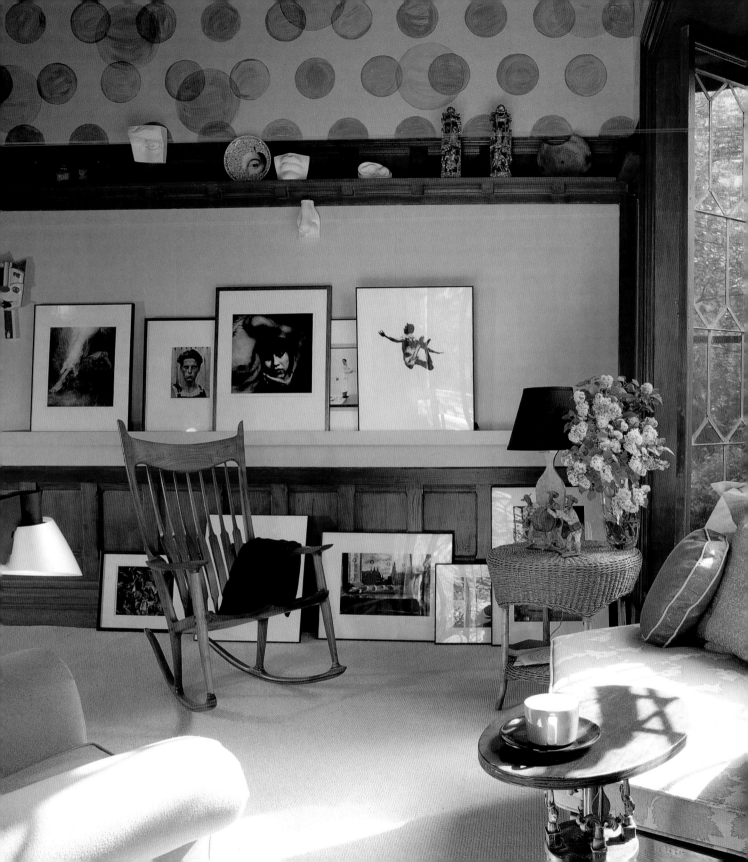

DISPLAYING PHOTOGRAPHY

Photography, beautifully framed and presented with clarity, gives rooms new focus and graphic drama.

Richard Avedon once said that photographs are the only great works of art he could afford to collect. Black-and-white photography can be purchased for a few dollars or a few thousand dollars. It's not surprising that collecting photography, both old and new, has become a great obsession.

Serious photography collectors say that when you're just getting started, you should buy what thrills you. Begin by purchasing photos you can't live without, and a collection will naturally follow.

To find well-priced photographs, visit art schools and support new talent by purchasing student work. Flea markets can be a good source of off-beat old photography and antique photo plates. City and small-town charity shops, junk shops, antique shops, and rummage stores often have old photographs hidden away. Historic photos can be among the most intriguing.

Auctions can be an excellent place to make serendipitous discoveries and find well-priced works. To learn more about photography techniques, study the work of famous photographers and join photography groups at local art and photography museums. To make your own prints, take courses in photography at university extensions or city colleges.

When purchasing photography, the image should please or disturb or inspire you. Let the image reveal itself, then savor the composition, the light and contrast, tones, the focus, the rhythm and emotion of the work.

Find a good framer and learn how to present the work with different mattes and styles of frames.

While it is usually best to choose a simple frame — maple, gilded, glossy black, or plain white — there are no rules. An elaborate old gilt frame may be the perfect setting for certain photographs.

And a broad black frame with some carved texture may be the most unexpected outline for a delicate and dreamy old pho-

tograph. Often it is best to keep the matting and the presentation free of pattern and color. Black-and-white photography seems to look most appropriate floating in simple white or palest ivory card. Some purists select antique frames for old prints, while professional framers usually opt for clear geometry (and just a sliver of it). Experiment and give each photograph its due.

ABOVE San Francisco interior designer Arnelle Kase uses photography and black-and-white prints deftly and to fine effect in the living room and entry hall. Simple frames, straightforward symmetry, and careful placement give a harmonious impression. Pale gray-green walls present the prints well. The linen-upholstered chair was a lucky find at a French antiques gallery.

OPPOSITE In a living room/study at the historic Stag's Leap Winery residence, black-and-white photography is a perfect counterpoint to stained-glass windows and substantial furniture. Narrow shelves are the perfect support for an ever changing collection of photography. Among the owner's favorite photographers: Henri Cartier-Bresson, Edward Weston, Imogen Cunningham, Ruth Bernhard.

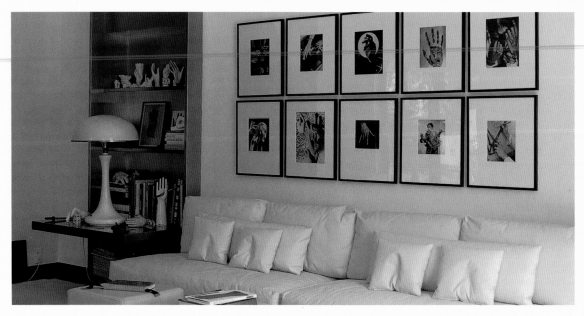

ECLECTIC A collection can be either very eclectic or totally focused. Brady likes to have many different styles and subjects mixed together. He believes that it is important to have an emotional connection with a work, and not to buy coldly and with calculation for investment. The photography should be for enjoyment—not money in the bank.

PRESENTATION Some fine photography should stand alone on a pristine white wall. When the work is really powerful, it can command attention and be the focus point of a room. But most works can be integrated with objects, an antique flower painting, etchings, drawings, or perhaps a plaster or gilt sconce. Don't limit a grouping only to photography.

EXPRESSIVE Self-expression is more important than worrying whether you have arranged your art correctly. Let the works, your taste, your sense of humor, and your rooms dictate. A collection can be all faces, landscapes, abstract, historic scenes, shells, fashion classics, the work of one photographer—or far-ranging.

IN-PROGRESS The collection does not have to be complete before you start hanging it on the wall. Leave room for later additions. Make the display open-ended.

LOCATION It's not necessary to commit everything to the wall immediately. Stephen Brady usually knows exactly where he wants to hang new pieces, but he often props them on a cabinet or on shelves to ponder and then position later.

RELAXED Brady often stands framed photography or his paintings on the floor when they first arrive at his house. Sometimes he does not have enough wall space and he wants to see the new work's relationship with old favorites. Sometimes they stay propped up against a wall. Brady likes a relaxed look.

ABOVE Dr. Leo Keoshian's famous collection of photographs of hands creates a superbly symmetrical impression on his living room wall. It's balanced by John Dickinson's cotton canvas sofa.

OPPOSITE In interior designer Stephen Brady's San Francisco apartment, photography is shown to advantage on paneled walls. Brady believes in mixing photography with paintings, sculpture, and prints to invent a wallscape that pleases his eye and reveals his interests. Here, images by Bruce Weber, Edward S. Curtis and Kurt Markus are mixed with flea-market paintings, drawings, and objets trouvés.

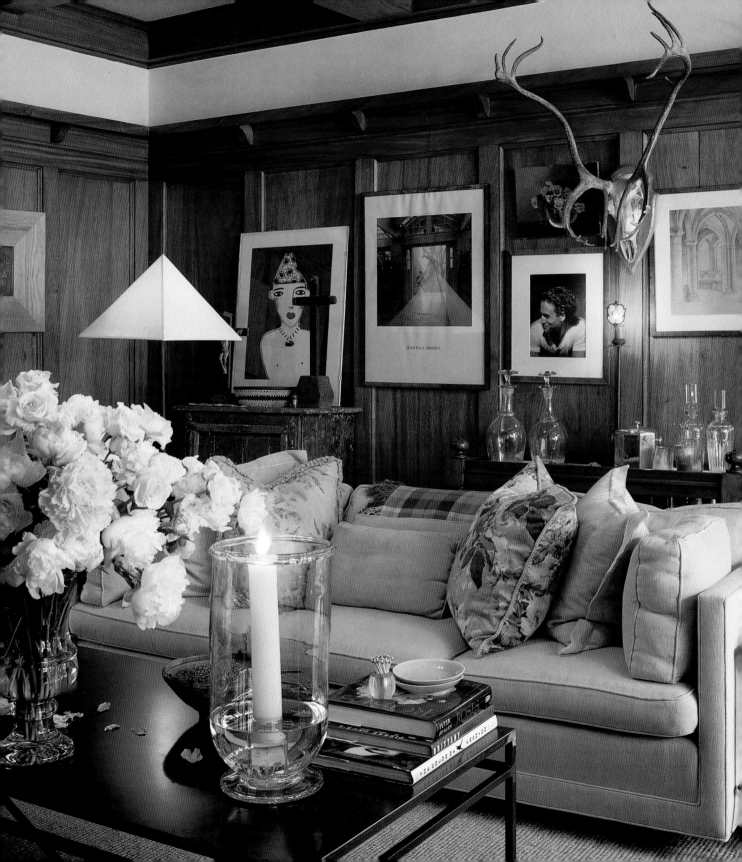

JEAN PAUL BROHEZ

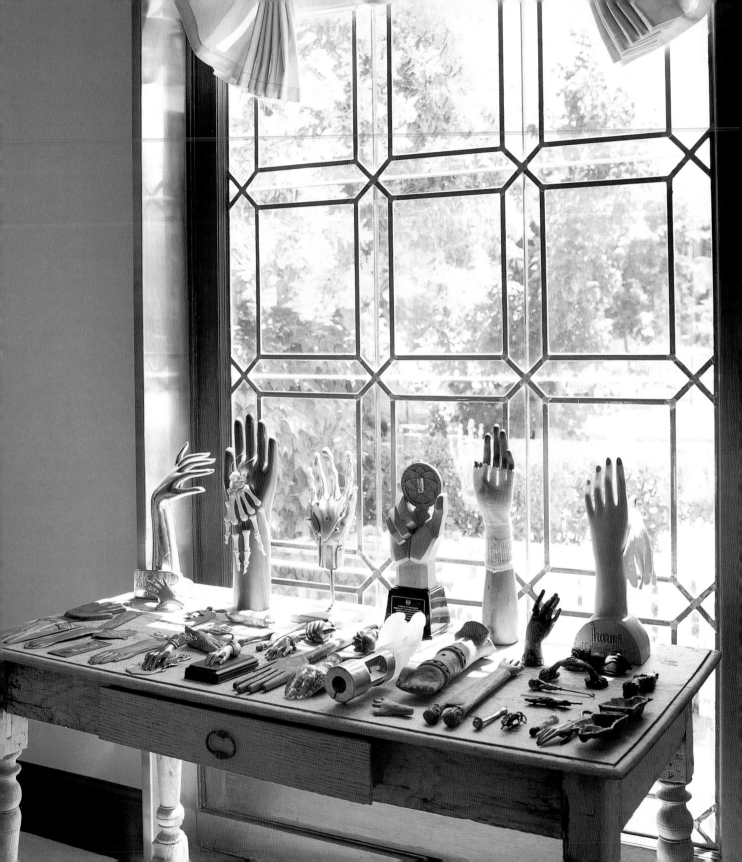

DISPLAYING COLLECTIONS

Entertain your eye, please your senses. Present your
collections with conviction and imagination.

San Francisco interior designer Ann Jones has been gathering things she loves ever since she can remember. "I grew up in Florida gathering shells on the beach, and quickly moved on to collecting beach glass, bracelets, postcards, and rhinestone jewelry," recalled Jones.

At antiques shops and garage sales, she would see pressed-glass cakestands or bamboo and silver bracelets and had to begin a collection.

For Jones, part of the pleasure of collecting is displaying everything so that it can be enjoyed and admired. She began arranging the objects of her affection on tabletops, on trays, in boxes, on shelves and dresser tops in her girlhood bedroom. "I always select and buy from the heart," noted Jones, now a partner with Sheelagh Sloan in Sloan & Jones, a Sonoma antiques store. "I love things that evoke good feelings. I never buy as an investment. Anyway, I get too attached to my collections to ever part with them."

Jones' collections now include Imari plates, antique silverware, European hand-embroidered linen napkins, ornately bound vintage books, miniature chairs, and antique kitchen utensils. "You have to have your favorite things out on tables and in bookshelves in order to see them," she said. "When you can see them every day, you learn more about your collections. It's a way of educating your eye."

Twenty years ago Jones started collecting lacquer trays and glass pedestals to use for presenting her bracelets and silverware. "The minute you realize you've started collecting Clarice Cliff pottery or antique pens, you have to figure out a way to display them," she said. "It's no fun to have them all hidden away in drawers or boxes."

She occasionally buys from antiques shops and seeks out quirky and whimsical objects at random from garage sales and swap meets. "I never like to buy things that are endorsed as being desirable," she noted. "I want to find cool stuff before everyone else does. That's what makes this treasure hunt fun."

As soon as Jones gets her bounty home, she starts arranging her finds.

"The best way to show collections in a strong, cohesive manner is to contain them on a stand, on a tabletop, or on a tray," she said. "You also need to use rosewood pottery stands, books, or Lucite squares to stand things on to give your arrangements different heights and some texture."

Jones said she is not fussy about the condition of each piece, and will readily purchase a book or a tiny chair with nicks or cracks and other signs of wear. Mixing old and new objects in a display give a grouping character and personality.

"I'm always ready to start a new collection, so it may be a group of green things, or things that are round," said the designer. "I have a collection of antique boxes and am crazy about old wooden knitting needles. I love the challenge of showing their beauty and making them look interesting. I have a friend who collects antique cameras. He displays them

OPPOSITE Dr. Leo Keoshian, noted hand surgeon, has a museum-quality collection of hand models. Deftly presented, their varied styles and provenances make for a compelling display.

on shelves so that they can be seen and appreciated. Another friend collects beaded evening bags. They're delicate, so she shows them in lighted cabinets.

"The most important point about collecting is to keep everything together," said Jones. "Don't dot them around the house. There's strength in numbers."

The designer also prefers loose groups rather than strict regimentation. "Don't line up your porcelains or your candlesticks like soldiers in formation," she said. "That's very static-looking and boring. Instead, vary the heights and shapes. Create contrast and variety within a grouping."

The other reason to take a group approach is that it makes a strong statement. "All the pieces say more as a group than individually," said Jones. "That's why I particularly like collecting objects like antique silver trophies and lacquer trays. They're 'workers.' I can simply display them, or the trophy cups can hold flowers. The trays can hold old books or bunches of old spoons."

Jones suggests changing displays often. "Move your collections around if possible," she said. "If they stand there year after year you stop appreciating what you love. Weed out pieces of lesser quality. That's how your collections evolve and improve and you become more discerning."

BELOW LEFT Painter Carlo Marchiori nestles his collection of Venetian masks, like ghostly spectators, in an old Italian armoire.

BELOW RIGHT Jean Thompson banks vivid pink roses, Mexican mercury glass vases, Oaxacan folk arts, and old silver on tables and a mantel to great effect.

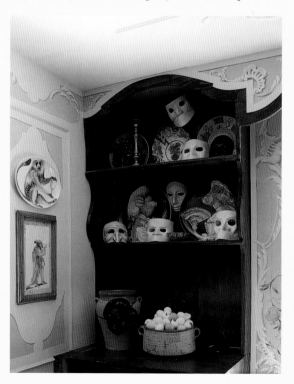

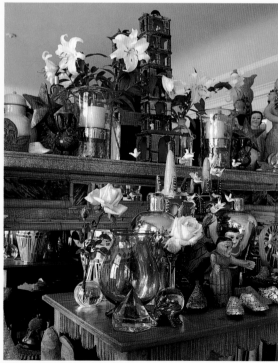

NATURE OBJECTS First get over the intimidation factor. Collections don't have to be priceless, rare, or even antique to be wonderful. In fact, some of the most personal and visually remarkable collections can be from natural objects discovered on a walk in the woods, a stroll along the beach, or a hike in the mountain. Mounds of aqua and white beach glass on a rustic table, piles of black-and-white striped river rocks in an old bamboo basket, or dried autumn sycamore leaves collected in New York's Central Park displayed in gilt frames will look wonderful.

GROUP ITEMS There is strength in numbers. Arrange your favorite collections together on a tabletop, on a tray, on shelves, along a mantel, or in a cabinet for most impact. Never dot them randomly around the room. That gives rooms a "restless" look and dissipates the power of a collection.

VARIETY Aim for texture, variation, and grace. Display bottles or ceramics of different styles and shapes by color. A collection of indigo blue bottles and vases gathered on a kitchen window sill, or a gathering of non-matching old green *majolica* pitchers or white ironstone bowls on wall shelves give a pleasing

overall impression. Remember, all whites go well together.

PRESENTATION All together now: To show off your beloved objects as an intentional, meaningful collection, present them as a cohesive but not too stiff group. Display them so that each can be viewed individually, and so that the complete collection makes a statement.

PAIRING ITEMS Pairs of special objects have great presence and power. A pair of shagreen boxes on an old painted table, or a pair of large white conch shells on a red Chinese lacquer table look sculptural and elegant beside clear glass vases of garden flowers.

ASYMMETRY To give display more dimension, arrange objects at different heights. Set some on Lucite or rosewood stands, others on top of leather-bound books.

FLEA MARKET COLLECTORS
Avid collectors collect for sheer pleasure rather than for investment. They try to avoid the obvious — silver-plated candlesticks, fifties lunchboxes, paperweights, perfume bottles, miniature Limoges porcelain boxes, or humdrum crystal. Humor and wit are important to flea-market fiends. Not every collection

should be dead serious. The following affordable collectibles could get you started:

California art pottery of the twenties, thirties and forties. Each studio has its proponents. Some collectors buy only green pottery, some only Fulper.

Czechoslovakian pottery and glass. It's very colorful and whimsical, and often combines romantic airbrushed or stenciled imagery with art deco motifs.

Mission furniture. Stickley has gone through the roof in prices, but you can often make great finds of vintage Mission chairs with great proportions and a pleasing patina. Arts & Crafts pottery, lamps, decorative objects and furniture make many collectors' hearts beat faster.

Bakelite radios from the thirties to the fifties. Wild colors, friendly shapes.

Vintage utilitarian objects like coat hangers, small farm tools, handcrafted trade tools, and old rusty watering cans. Some collectors are looking for (almost) obsolete objects such as typewriters, slide rules, old box cameras, record turntables, and outdated kitchen gadgets. Sculptural

kitchen whisks or copper utensils make great displays.

Some people avidly collect stuff that others may consider just junk. Wonky lamps, chipped restaurant ware from the fifties, corny and kitschy Americana, worn children's books, tableware from long-forgotten hotels and resorts, and goofy plastic figures all have their devotees.

Southwestern pottery, Arts & Crafts pottery, and Indian baskets. Many flea-market foragers say prices are now out of their league and the hunt has cooled. Others search for occasional bargains — the rare, unnoticed, and underpriced Indian craft.

Cowboy boots memorabilia, and furniture are setting some fanatics afire. Other collectors consider the whole genre trite.

Garden ornament. Sundials, stone urns, or lead planters with the patina of age.

Rust-enhanced metal outdoor furniture. Porch tables and chairs and lawn chairs bring on bursts of nostalgia. Rusted vintage bicycles and iron beds that look as if they're been left out in the rain are great-looking in today's decor.

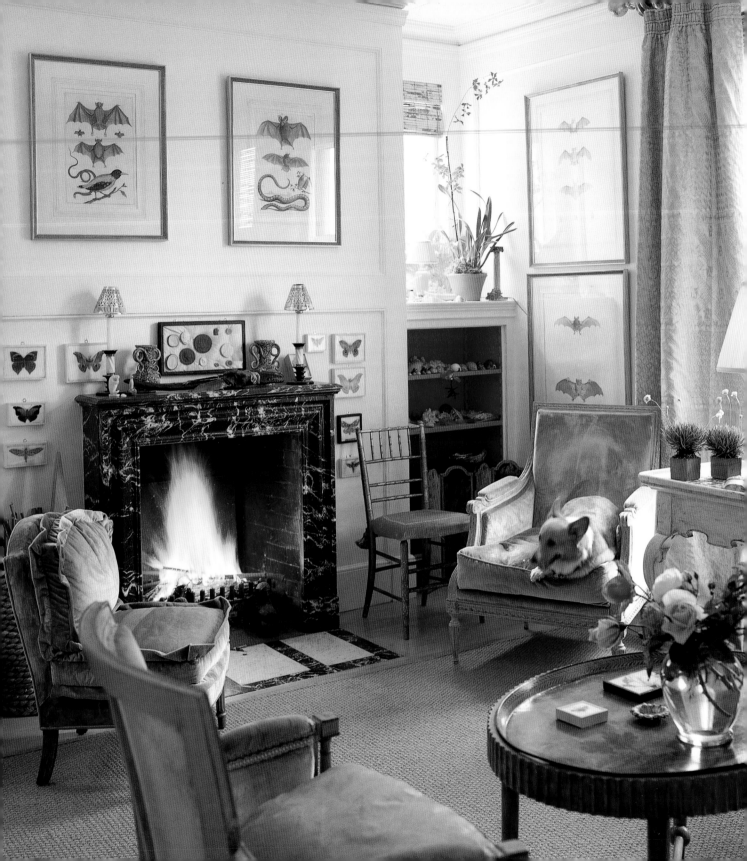

SMART ANTIQUES COLLECTING

Don't be intimidated by antiques; do buy the best quality you can afford. Choose well, and they'll accompany you throughout your life.

Los Angeles interior designer Michael Smith is admired for the way he uses antiques in a subtle, unpretentious way. His practiced hand is evident in his new Santa Monica design store, Jasper, and in the rooms of his many celebrity clients.

"My work has tended to be less formal because of the way Californians live," said Smith, "No one wants intimidating furniture that's stiff and starchy. You should be able to use your rooms every day, to relax and entertain there."

He can, when asked, fashion rooms with a grand, formal look and make them very inviting. "It's important to realize that eighteenth-century French furniture can be comfortable and very functional and not at all uptight," said Smith. "Used in a carefully edited room that is contemporary in feeling, Louis Seize chairs can be light, with great purity of line. They need not look pretentious."

Smith said that to create rooms that are truly personal—with or without a designer or architect—takes a great deal of trial and error. "Buying antiques of whatever style or period you favor gives an opportunity to experiment," noted Smith, who visits the top *antiquaires* for his clients, as well as venerated weekend flea markets in Paris, New York, Long Beach, and Pasadena to find treasures for himself.

"Since most people have trouble envisioning custom-made furniture, antiques give you the advantage of offering no surprises," Smith said. "You can buy an antique or vintage table, bring it home and live with it and get to know it. Antiques are the pieces you keep and appreciate more over time."

Smith insists that the days of theme designer—devising a pretentious "country squire" look or the Santa Fe look with all the clichés—are over. "Your house must be relevant to your life," said the designer. "Decorators have often been the worst perpetrators of a 'look' foisted on a client. I consider it unprofessional and boring to design by rote."

Rooms with antiques should not be theatrical or showy unless that's what you truly are, he said. "Formal English manor style or French chateau look-alike rooms in the Hollywood Hills are probably inappropriate and possibly laughable," he noted. Most people don't realize that traditional rooms cry out for the contrast of smoothly reductive twentieth-century pieces to give them an edge. Equally, cool, contemporary rooms demand the richness, heft, and surprise of well-crafted antiques.

Smith himself lives in a modern penthouse in Santa Monica with a handsome Anglo-Dutch sideboard in his all-white bedroom. A Regency sofa upholstered in leather is flanked by a pair of steel-and-plywood Charles Eames bookcases from the fifties.

"I bought the antiques, as I did the modern pieces, for their line and integrity," he said. "Only after I bought them did I think of putting them together. They will also work later in other houses, other rooms."

He avoids the obvious "trophy" antiques, those overly gilded baroque chairs and grandiose rococo sofas that look as if they belong on a stage set, not a house.

OPPOSITE Antiques are dog-friendly and enhance a small apartment. Thomas Bennett was a lifelong collector of Directoire-style chairs, bat prints, butterflies.

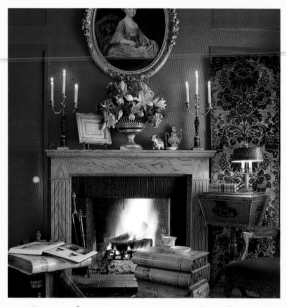

Buying for status is not something he or his clients are interested in. "I think people are often surprised to discover that I use low-key antiques in my clients' houses a lot. They're more subtle, don't demand attention," said Smith. "The general perception of Hollywood is that stars live in rooms that look like high-style movie sets. Nothing could be further from the truth. They want their houses to be personal, comfortable, and above all individual. Carefully chosen, quality antiques give their rooms character."

For one of his clients, a film producer, Smith designed a Malibu family house that is both stylish and comfortable. Colors are muted. "Young Hollywood no longer wants rooms that are larger than life," said Smith.

Smith tells new clients that antiques are not solely for novelty. Nor are they just for traditional rooms. "Antiques bring so much to a room and work with everything," Smith said. "It's never the pair of

eighteenth-century French chairs you sell when you move. They're yours for life. You don't tire of your beloved English writing table. They only get better over the years. I encourage people to be brave and think of antiques in their own way."

Antiques are more versatile than brand new furniture. Nicks and chips and signs of loving use and wear only confer more character. "An antique mahogany tea table can be used as a bedside table, an end table, or a lamp table," Smith said. "To me, a new coffee table is just a coffee table."

Some people are afraid to start collecting antiques because they are puzzled by their mystique. Antique shops can be intimidating.

"An entire shop filled with antiques can be daunting," he admitted. "In the store, that scholarly approach and seriousness are appropriate. That doesn't mean you have to aim for museum-like authenticity. It's best to mix periods in your own rooms—give antiques your own spin and don't limit your choices."

For beginners, Smith suggests attending lectures and seminars, poring over auction catalogs and looking closely at antiques offered. "Start with perhaps a pair of chairs," he said. "Go looking for antiques with a sense of curiosity. You may search for a mahogany sideboard and find instead a smashing painted hope chest. Always be open-minded."

"Collecting antiques should be done in the most optimistic way," said Smith. "Buy the best you can afford—and enjoy your favorite pieces every day."

ABOVE Robert Domergue was not aiming for a period room replica, but rather boldness, charm, and warmth.

OPPOSITE San Francisco designer Anthony Hail has collected the best antiques. Chinese porcelains, a French mirror, Scandinavian antiques—all live happily together in his living room.

AVOID THEMES Create your own look with your favorite collections, plus unexpected combinations of antique furniture and vintage fabrics with new furnishings. Avoid a set "theme." Theme design always looks impersonal, like a showroom or a hotel. And worse, it is by nature full of clichés.

FUNCTIONAL Antique furniture is not necessarily fragile or precious — with certain exceptions. If it has stood the test of time, you can continue to use that chair, table, or desk every day.

ECLECTICISM Mix woods and styles of antiques for best effect. There's nothing more glamorous than combining a delicate classic Swedish pale Karelian birch writing table with an eighteenth-century English mahogany chair. (Mixing woods and styles also suggests that furniture was collected over decades — not merely years or months.)

INVESTMENT In the long term, many antiques are better value than expensive reproduction furniture. The antique chair or hall table will continue to hold (or increase) its value; the reproduction will become used furniture.

INFORMAL Antiques need not be stuffy or formal. Only the way you arrange them or use them makes them stiff or intimidating. Introduce very strong, rather architectural antiques — possibly Biedermeier — into a contemporary minimalist setting for pleasing effect.

KEEP INFORMED Know what you're buying. Be sure the dealer you're purchasing from is reputable. Inspect inside drawers, beneath table tops, behind dressers for clues that the antique may not be as described. Use common sense and caution regarding asking prices and provenance.

TIMELESS QUALITY Avoid fashions and fads in antiques. You'll soon tire of those "trendy" antiques. Instead, educate your eye and seek out vintage furniture with lasting, timeless design and enduring quality.

APPROPRIATENESS Trust your instincts and your eyes. Buy antiques for their quality, look, comfort, and appropriateness to your life and to the architecture of your house.

REFINISHING Never over-restore antiques. Too much wax or overzealous cleaning, repair and restoration take away all charm and character from French antique farm tables or early American furniture. The point is not to make it look "new" or, even worse, like a reproduction.

VARIETY Never be afraid to mix periods and styles of antiques. Ten or twelve Arts & Crafts chairs lined up around a dining table, no matter how handsome, can be a daunting and dull prospect. Contrasting these severe brown Craftsman chairs with lighthearted contemporary Italian chairs shows them all off to advantage.

CHOOSING A GREAT SOFA

**This may be the favored spot where families spend the most time.
Select patiently and wisely, and don't forget to perform a "taste test."**

How do you choose the right sofa from the thousands on display in furniture stores and showrooms? For your investment of $1,500 or $2,000 and upwards, are you making the right choice?

"A sofa is probably the most expensive furniture purchase other than antiques you'll make in your lifetime, so it's important to do some research," noted San Francisco interior designer Gary Hutton. "This is not something you choose instantly with a vague idea that it might fit. You can't take an unsuitable sofa back, especially if it was custom-upholstered."

Hutton advised against being seduced by a trendy shape, a colorful fabric, sexy arms, extravagant leather, romantic tufting, or dramatic pillows. "Think of a sofa as a lifetime proposition and seek out a somewhat simple, timeless style. Spend a little more to get the best you can afford," said Hutton. "A custom-made sofa may initially seem very costly, but quality sofas with hardwood frames will last for several decades. The upholstery may need to be redone, and cushions might need refilling, but a $5,500 sofa that you sit on for 40 years is a fine investment."

Hutton suggested focusing on comfort, not just appearance. Examine the shape, the dimensions, and construction of the sofa, and worry about the fabric and upholstery last. "A systematic, logical way to buy a sofa is to look at a wide range of sofas in all price points," said Hutton, who has been choosing and designing sofas for clients for more than 18 years. "The more sofas you see, the more educated you become about what pleases you, what fits your style, and what represents good value to you," said Hutton,

who recommends sitting in sofas, prodding and poking them, and checking the pillows and the legs.

Sofas have two basic categories—more elaborate, curvy traditional shapes and rather clean-lined, tailored contemporary designs. Paying attention to the shape and settling on a style is initially more important than worrying about the color or the fabric.

The designer warns first-time sofa buyers to steer clear of exaggerated shapes. An enormous elephantine roll-arm sofa with tufting and fringe may seem glamorous, but it will most likely look pretentious in a modest apartment or country cottage. On the other hand, an updated traditional sofa with straightforward proportions, uncomplicated tailoring, and comfortable seating will have real staying power in any living room. "The shape of a sofa should not attract too much attention because its size already draws the eye," he said.

Hutton said that a buyer can never go wrong with a tailored Tuxedo-style sofa with arms and back of equal height. "A Tuxedo-style sofa, which many manufacturers offer, is a versatile shape because it provides a simple, square background for curvy antiques, a thirties chair, or French chairs. It doesn't make too much of a statement," he said. "This sofa style can be upholstered in a range of fabrics for different effects."

It's important, too, to consider the way a sofa is used and how often. The designer noted that there are many different ways to achieve the look in a room, but if the shape and size of the sofa do not

OPPOSITE Los Angeles costume designer Theadora Van Runkle adds bold curves to her living room with her striped linen sofa.

accommodate the way one likes to sit or lie in it, then it's an inappropriate style.

For example, someone who likes to sit square on a sofa and have an arm to lean on will not be comfortable in a sofa with a very low arm and a deep seat with squishy pillows. People who like to sit forward on a sofa will often find a shallower, high sofa more congenial because it will support the back well. A tailored sofa with a firm seat allows for a more elegant posture than a low sofa with loose, floppy pillows. Families who like to recline on their sofa should seek out a well-padded sofa with low arms and adjustable pillows that support the back and the head.

Avoid Fussy Design

Hutton, whose taste veers to classic, timeless design, recommends avoiding overly fussy, over-patterned, extremely frou-frou sofas. He warns against brightly colored upholstery generally, and particularly sofas with aggressive patterns that take over a room. He recommends more pared-down designs that are not too elaborate or too dressed up with fringes, buttons, overstuffed pillows, floppy slipcovers, or flouncy skirts. In good design, there are always exceptions. Sometimes a souped-up or totally "done" sofa will look as chic and definitive as a Chanel suit—and be just the ticket for a dressy room.

"I usually warn my clients to ignore the exaggerated shape or fashionable color that may seem to make a statement now," warned Hutton. "In three or five years, its time will be past. Sometimes that's fine—it was entertaining and fun. But if you want

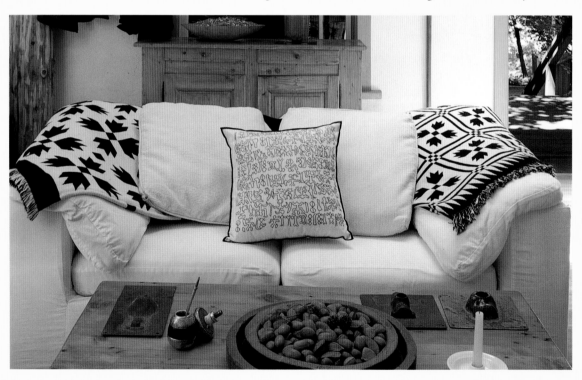

the sofa to last forever, you will tire of bold colors, and regret the insistent nature of its style."

Hutton prefers upholstery and shapes that are friendly, versatile, and welcoming rather than dramatic or hard-edge. "This means eliminating sofas with skimpy, poky arms or stingy cushions that afford little comfort," he said. "If you like a tailored look and a tightly upholstered back and arms, the sofa should not be so rigid or hard that you are uncomfortable."

Style Clues

"The first consideration with a sofa's style is suitability," said Hutton, quoting the revered interior designer Elsie de Wolfe. For sofa novices, Hutton recommends taking cues from the style of the house, the architecture, and its setting. For example, a traditional, low-key thirties Spanish- or Mediterranean-style house would suggest a damask-upholstered traditional style with a scroll arm rather than a hyper-styled modern Italian red leather sofa—unless you can handle contradiction and counterpoint well…and carry it through in the design.

Apartment dwellers should be practical and consider a versatile, workable style, since the sofa will make a later appearance in a new house or a city condominium. A curvy Victorian sofa with brocade upholstery will hardly look at home in a fifties ranch-style house.

For an Arts & Crafts interior, Hutton likes a traditional roll-arm sofa with upholstered legs or wooden legs rather than a skirt. It should have a simple outline and be upholstered either in leather or a fabric with a handwoven quality. Tapestry or coarse-textured wool would be excellent choices.

In a Victorian interior with high ceilings, a high-backed sofa upholstered in velvet or chenille with

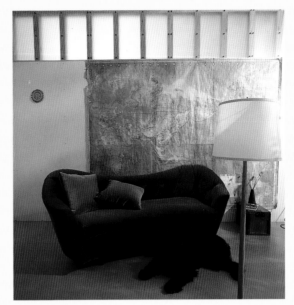

tufting and perhaps fringe (like the "Syrie Maugham" sofa) recalls a gilded age without being too ornate.

For a beach house or a weekend cottage, Hutton recommends a casual sofa. He likes Pottery Barn's or Beverly's modified Tuxedo style with washed-linen slipcovers and generous pillows.

Sofa Sizes

Sofas are made in standard six-foot, seven-foot and eight-foot widths, but it is often difficult to select a size. Hutton's rule of thumb for selecting the appropriate dimension is that there should be at least three feet of wall space on each end of the sofa to accommodate tables, or a club chair.

Along a 12-foot wall, the sofa should probably not be longer than six feet to allow for a three-foot-

ABOVE Madeleine Corson and Thomas Heinser's velvet Dialogica sofa in their San Francisco house. A map becomes instant art.

OPPOSITE Fashion designer Isda Funari gives a cotton sofa dramatic pattern with graphic throws and pillows.

To get the best quality sofa for your money, San Francisco upholsterer Lauren Berger says, it's wise before purchasing to do a "comfort test," to investigate the insides and the structural materials of your sofa. Berger suggests first sitting in the sofa, then leaning back and testing the arms and back for support. Is the arm height comfortable? Do the pillows feel right? Is the seat supportive or too low?

Take a look underneath the sofa. Does it seem carefully crafted and finished? Ask about all materials used. There are six specific parts to check for quality and sturdiness:

THE FRAME The sofa and its wood frame should feel solid and heavy. Top-quality frames are made with kiln-dried hardwood, such as oak, ash, hickory, birch, maple, or poplar. Make sure that the frame doesn't wobble or creak. The joinery should be dowelled or double-dowelled or screwed and glued together. Corner blocks give the frame extra stability. Be certain that European sofas with metal frames are securely bolted and welded.

LEGS In top-quality sofas, the legs are an integral extension of the frame. Legs attached with screws are more likely to wobble or break. All four legs should match.

SPRINGS Upholstered sofas should have springs for comfort and durability. Top-quality handcrafted sofas like those manufactured by Randolph & Hein in San Francisco use steel coil springs individually connected with steel clips onto a base of heavy-duty webbing. Eight-way hand-tied springs are the very best choice. You should not feel or hear the springs through the upholstery fabric when you sit down.

PADDING Ample layers of top-quality padding are important for the longevity of the sofa as well as for comfort. All frames except those that are exposed should be padded with a quality material such as 100 percent cotton batting, jute and burlap. Springs should be well padded, and should not be visible through the stuffing.

CUSHIONING The best-quality pillow cushioning is a traditional mix of goose-down and feathers. Some newer synthetic materials (Dacron, for example) simulate the luxurious look of down, without the expense of down, and may allow the pillows to hold their shape better.

UPHOLSTERY Best-quality sofas have a layer of muslin stretched over the padding before the upholstery fabric is added. Check to be sure that the fabric used for the entire sofa also covers the seat. Be sure that the patterns of the fabrics are well matched, and that the upholstery is smooth and not lumpy.

BELOW Ann Jones dressed her daybed with luxurious Indian fabrics and downy pillows. Colors are rich and restful.

OPPOSITE Carlo Marchiori's upright sofa and small pillows are perfectly scaled for his winter parlor.

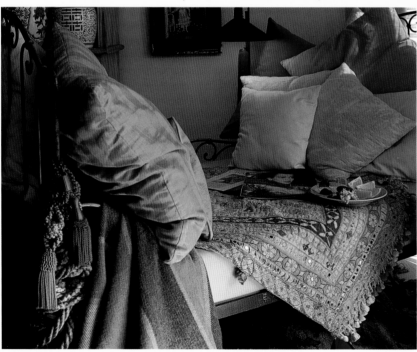

wide chair or a round table. When a sofa stands in the middle of a room facing the fireplace, it is important to allow 30 inches on at least one side for easy access.

The height of a sofa should not be more than 28 inches unless it will be used to partition off an area of the living room. When sofas are placed in front of windows, they should not be higher than the windowsills, Hutton noted.

Custom Design

When ordering a custom sofa, Hutton advises that it is best to keep the design simple, crisp, and understated. "Be satisfied with somewhat less design than a too-busy, confusing style," he said. "If you purchase a cream chenille upholstered sofa and it seems a bit plain or a little mousy, you can always add hand-embroidered pillows, antique silk pillows, or one or two tapestry pillows. Just don't overdo the pillows and throws and bolsters."

Too many pillows on a sofa not only add visual clutter to a room, they can also crowd the sofa and make it difficult to sit in. Pillows should not be too big or pretentious. They should be just large enough and firm enough to support your back or your head.

Sofa pillows shouldn't look like giant sacks of flour. And a row of square pillows should not be "styled" with a karate chop that makes the corners stick up like rabbit ears. Instead, square or rectangular pillows with down or feather-down fill will sit on the sofa attractively, ready to offer comfort and cosseting.

Fabric Selections

Choosing the appropriate fabric or leather can be tricky, according to Hutton, so it is often best to start with a neutral fabric with some texture, such as a chenille or a woven cotton or wool. "Textured fabrics

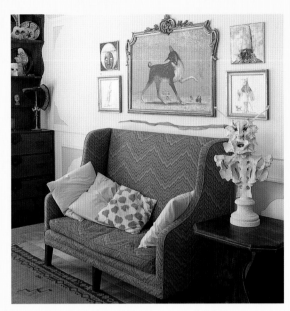

don't show wear or dust as much as smooth, plain fabrics," said Hutton. And neutral fabrics can always be dressed up with vintage or patterned pillows.

"I suggest avoiding big, bold patterns because I think you tire of them quickly," said the designer. "If you like pattern, consider a tone-on-tone damask. A subtle woven pattern, a neat stripe, or an embossed pattern or wool tweed would be sensible. Avoid odd colors—mustard, turquoise, acid green—because they are hard to match or coordinate with paints, carpets, and other fabrics."

"Washable slipcovers are ideal for families who use the sofa often," said Hutton. "But avoid the too relaxed, too droopy slipcover. A more tailored slipcover will look neater and not so disheveled with use."

And finally, before ordering a dream sofa, be sure to measure the widths of doors, entry foyer, and hallways carefully to be sure that the sofa can be brought into the house. If you live in an apartment, it is critical to check the dimensions of stairways.

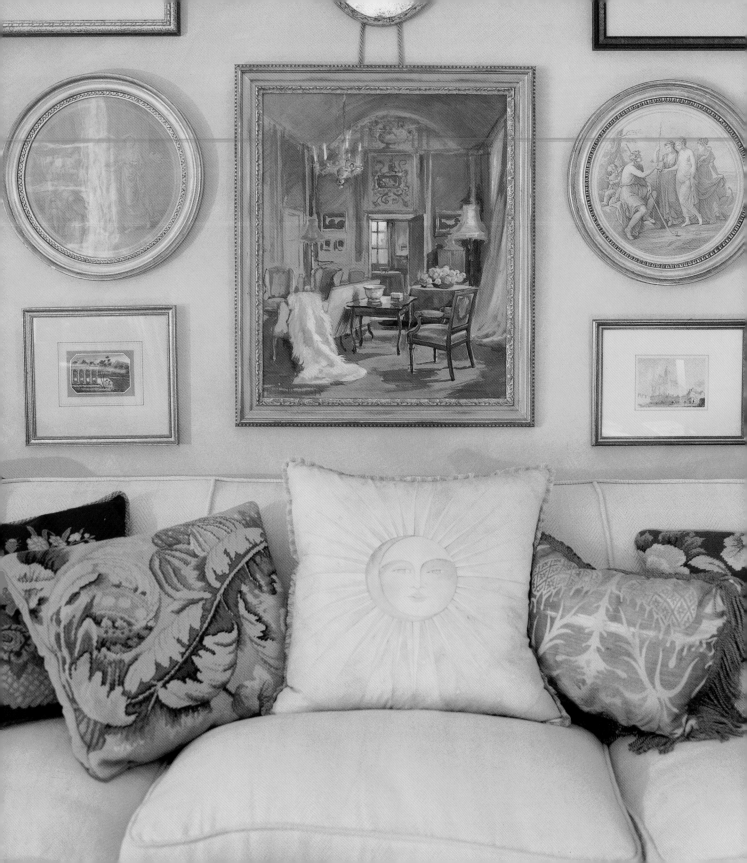

Los Angeles/Pasadena interior designer Kate Stamps is very opinionated about pillows. A partner with her husband, architect Odom Stamps, in Stamps & Stamps, Kate knows the right pillows will add richness, individuality, and allure to a chair or sofa.

FILLING Pillows must be down-filled or down-and-feather filled. When you have a deep seat, make the fill 50 percent down and 50 percent feathers so that the pillow is somewhat firm and supportive. When you have a shallower seat, make the pillow 100 percent down so that it's malleable and you have enough space to sit comfortably.

FABRIC Pillows should be made of intriguing fabrics — antique tapestry fragments, needlepoint, hand-painted silk, antique textiles, silk and wool embroidered fabrics, remnants discovered at flea markets. Some pillows can be in simple linen, damask, or textured cotton to serve as "background" to the more special ones.

MATCHING Use no more than two matching pillows. If the pillows are new and mass-produced, use no more than one. Massed pillows look like an assembly line production. Watch out, also, for overuse of emblems of the eighties — such as painted Auriculas on

silk, needlepoints of Redouté roses, certain chintzes — which can still be pretty if used sparingly.

SHAPE Use one or two unusual custom-made shapes such as ovals, hexagons, rounds, or long rectangular pillows. If you have a beautiful piece of fabric that is too small, oddly shaped, or off-center to use as a pillow front, make it into a panel. This is also a good way to refashion an old pillow. Down pillow inserts can be custom-made in any shape. No karate-chopped pillows. They look too Manhattan 1978.

EMBELLISH Forget the clichéd fat, multi-colored trim. Use wool, silk, or linen cording, preferably in one color or two very closely related colors. Antique tassels, faded and even a little tatty, look good on vintage fabrics. Avoid any shiny, glitzy trim — or any look that is too complicated, pretentious, labored, suburban-chateau, or tortured.

INVERT Turn new fabrics over to their reverse sides — then chintz looks older. You can also get a positive/negative effect with some woven fabrics, especially damasks and jacquards, when you do this. Then you can use two pillows of the same fabric together, to very different effect.

REINFORCE If the fabric is old and fragile, attach it to a backing and lightly quilt it in 1 1/2-inch diamonds. This will also add texture. It can add interest to a simple silk or a plain cotton, too.

PATTERNS Use a different color or pattern on each face of the pillow. Then you can change your look with the flip of a pillow. For example, pillows in summer brights on a white canvas slipcover can be flipped in winter to darker shades against the velvet upholstery of the couch. Or include a print on one side and a plain fabric on the back.

UNITE Use your cushions to bring disparate elements of the room together, to repeat a fabric you love, or to add interest to a monochromatic room. Plain pillows can tone down and break up the pattern of a too-busy sofa or chair.

OPPOSITE Kate Stamps loves to mix pillows along a down-filled sofa. Most of her pillows are either antique fabrics, hand-painted, or hand-stitched.

BELOW Designer Nick Mein used vintage fabrics to great effect in his Woodside country house. A phalanx of antique pillows marches along linen upholstery.

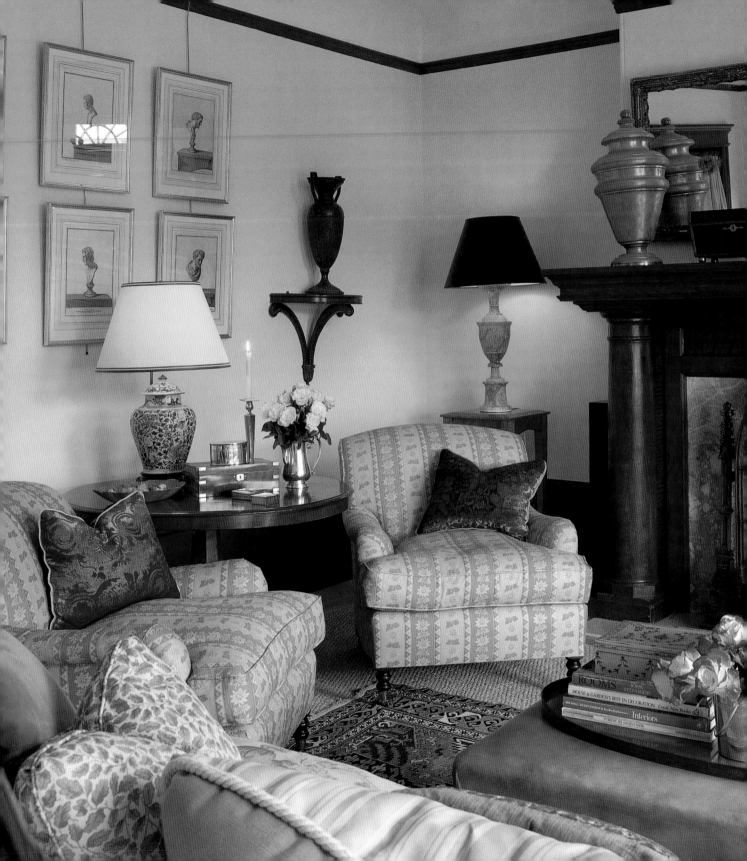

ALL ABOUT ARMCHAIRS

**Study all the newest armchairs before making this important purchase.
Be sure to inspect the innards and to "kick the tires" before buying.**

San Francico designer Suzanne Tucker believes that the armchair cushions must be well constructed, the skirt should not be too short, and the arms should cradle your arms and your back. The seat should support you just the way you like to sit.

"I enjoy beautiful armchairs," she said. "Silhouettes can be so graceful. When they're well made and have attractive lines, they're very inviting. But they have to feel good as well as look wonderful." Tucker said she believes in comfort and luxury—and finding a well-made chair that will last for decades.

"An armchair is an important, expensive purchase, and its every detail must be right," said Tucker, a partner with Timothy Marks in the San Francisco design firm Tucker & Marks. "The scale and proportion must be right for your room—not too small and not huge. The shape should not be too exaggerated."

Tucker believes that very inexpensive, foam-filled chairs are generally not a good purchase over time. They wear out or fall apart and cannot be reupholstered or repaired satisfactorily. "When you spend more for a fine-quality chair, it's a good investment," she said. "A spring-base custom-made armchair will 'sit' better for longer than a glued-together chair with a foam seat cushion. Cheap chairs will eventually "bottom out." You start to feel the frame through the flimsy padding, and you can't refill it."

Tucker chooses armchair fabrics carefully. "I insist that the fabric chosen for upholstery—whether it's linen, cotton, chenille, velvet, or wool—should feel good to touch," Tucker said. "You must enjoy sitting in the chair."

She's particularly fond of cotton chenille for its silky feeling and its durability. It also has a luxurious look. "I think chairs should be beautiful but they should not look and feel too precious," said Tucker. "People should feel invited into the chair rather than feel that they have to perch and be on their best behavior. Even in a formal room people should be comfortable."

Her ideal custom-made chair will have some down fill, but she's pragmatic about using down. "When you sit on all-down-filled seat cushions, it's gorgeous. It's like sitting on a cloud," said Tucker. "But to maintain the loft of the down, you've got to shake them and get air into them to get them full and fluffy again. Some people like that European squished look of down cushions. Others love the idea but find them too much work."

Added drawbacks of an all-down cushion, said Tucker, are that they may not have enough support for some people, and the down may need to be refilled as it naturally flattens. That's why most fine upholsterers make a combination down/feather cushion, or wrap down around a special polyester cushion core. "A down pillow with a firm core maintains its shape and lofts back up when you rise from the chair," Tucker said.

"You should sit in a chair and see where it hits the back of your knees," the designer said. "The back of your legs should be supported. You should not be

OPPOSITE Elegance and comfort: In Patrick Wade and David DeMattei's San Francisco house, George Smith chairs are down-filled and inviting. Velvet pillows add glamor.

pushed forward or pitched back too deep in the seat."

Tucker dislikes chairs with shallow seats that don't support, and arms that are too high. "Arms should feel right for you, but the fit is very individual—there are no rules here," she said. "If you'll be using the chair for reading, be sure that you can relax with your book at the right height—not pinched at your side or raised too high."

Tucker noted that while large, overstuffed furniture may seem like a dream come true, it's not very versatile and can't be easily moved. "A big chair can be very uncomfortable if the arms are too high and the seat too deep," she said. "It should be able to be moved into a conversational group, or closer to the fire, or to catch better light when you're reading. A giant chair is not that versatile."

The designer, who trained with San Francisco interior designer Michael Taylor, works closely with her upholsterer to finesse frames and fills, and fusses over fabrics and feathers.

"When it comes to fine armchairs, heaven is in the details, " Tucker said. "I know everyone is not as obsessed as I am with every welt, seam, cord, spring, and tilt, but it's those small details that add up to a really wonderful chair. If you plan to sit in it almost every day for 20 or 30 years, of course every detail should be great."

BELOW Michael Berman's Cubist chair, with its squared-off ebony arms, is a fine choice for this Pacific Palisades room.

OPPOSITE Tom and Linda Scheibal's chair was given mustard legs and a snappy striped linen slipcover.

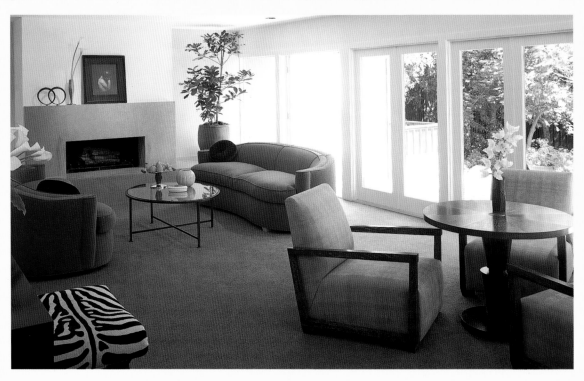

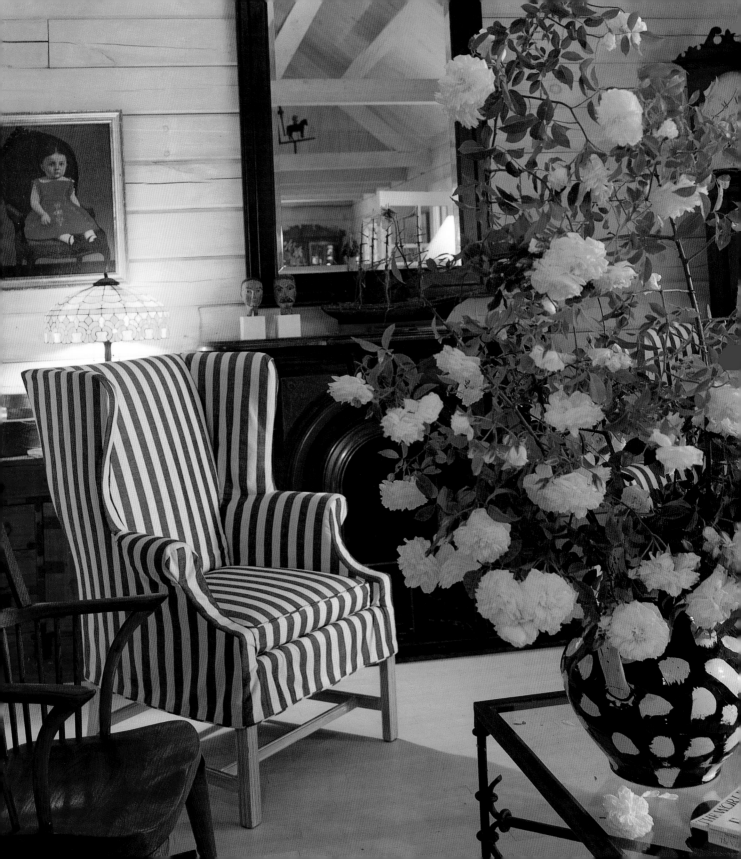

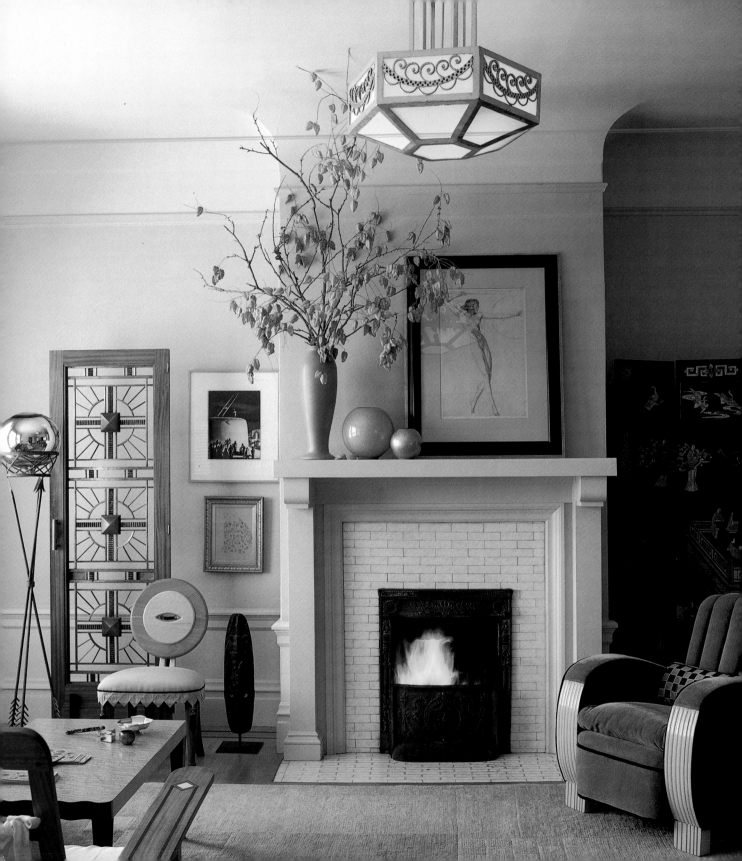

RESEARCH Take your time. This is a purchase that should last for many years. Don't rush your research or selection.

AFFORDABILITY Buy the best chair you can afford. Look for good "bones" — solid structure and good lines. A good upholstered chair with a hardwood frame, perhaps recovered once or twice, should be expected to last 40 or 50 years. Even an old chair bought at a tag sale to be reupholstered should be well constructed.

TESTING Be sure to "road test" many chairs before zeroing in on four or five. Sit in them. Feel the arms, and check the support beneath your knees. The "feel" is as important as the design.

LOCATION Consider the planned location of the chair and how it will be viewed in a room. If it will be seen from the back, be sure that the chair's sides and its back profile have attractive lines.

CONSTRUCTION Have an assistant turn the chair upside down to check the construction. Does it have jute webbing supporting the springs and base? Is it well finished?

QUALITY Check to be sure that the wood frame is secure and that the chair is steady and firm. Get information on how the frame is constructed. Is it a durable hardwood frame? Is it glued or doweled together? Firm dowels are best. Glue can become . . . unglued.

UPHOLSTERY Consider having a chair custom upholstered. You can have it made to your exact measurements and to suit its function. With custom designs, you can choose the fill that's most practical and comfortable, as well as the right combination of batting and padding. Custom manufacture may not take longer or be more costly than store-bought, off-the-floor designs. With custom design, you're choosing exactly the leather or fabric you like, and purchasing a one-of-a-kind piece.

HELP Experienced interior designers — who have designed and viewed thousands of armchairs — can be excellent guides in selecting chairs. They'll educate you on the finer points of tufting and cushions, and avert chair purchases made for emotional rather than logical reasons. Firm believers in making purchases with lasting value, designers will also choose the most appropriate textiles and work closely with an upholsterer to get the chair look and feel that's right.

FADS Don't be too trendy. Any design that's too exaggerated will date fast.

LEATHER Don't be too precious about leather. Buy the best quality — it should be supple — and let it age naturally.

BELOW An orange velvet chair at Madeleine Corson and Thomas Heinser's loft.

OPPOSITE Arnelle Kase found her handsome Deco chairs at a flea market.

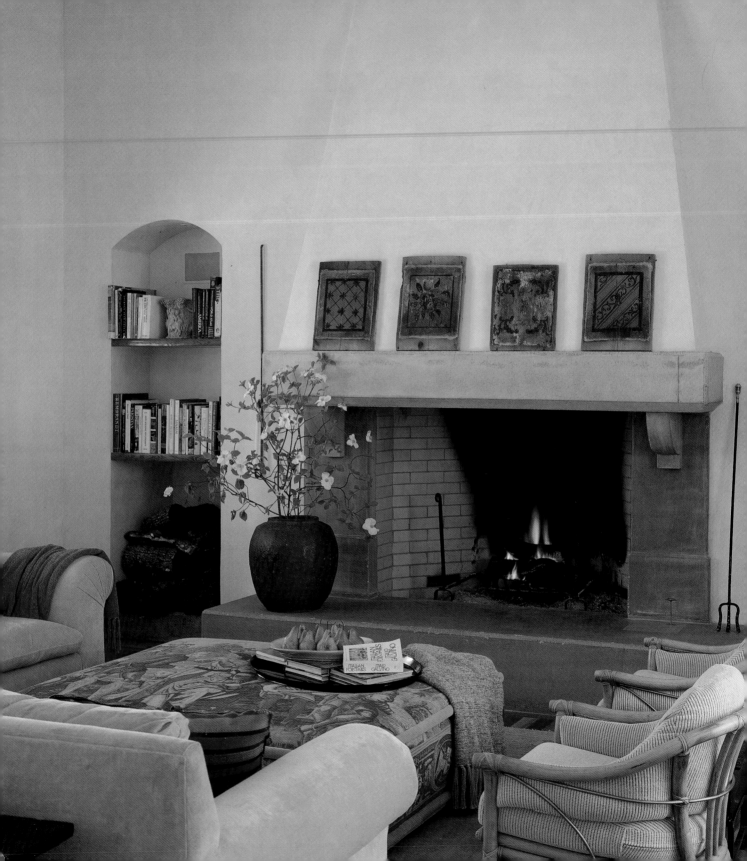

OTTOMANS, BENCHES, AND FOOTSTOOLS

Don't overlook these decorative and versatile pieces of furniture. Antique and modern, simple or elaborate, they're useful and friendly.

Ottomans are now an integral part of the interior design repertoire. Decorators have come to appreciate their endless versatility, their usefulness, comfort, and charm.

"I like ottomans and benches because they're very hardworking and they don't take up much visual space or add clutter in a room," said San Francisco interior designer Anthony Hail.

"You design a room with all the principal furniture and you still need smaller, incidental, moveable pieces such as an ottoman, an upholstered bench, a small table," Hail remarked. "You need additional seating. Sofas and chairs can't do it all."

Few pieces of furniture can offer as many fresh and friendly decorating options—and can serve both indoors or out on a terrace. Prop a stack of books or piles of magazines on a tufted leather or linen bench in the living room. Rest your feet or a tired child on a chenille ottoman in a home office. Push a tapestry-upholstered footstool under the coffee table for extra guest seating. Carry a lightweight ottoman onto the patio to turn a simple wicker or rattan armchair into a luxurious chaise longue.

In addition to the comfort and flexibility they offer, ottomans and benches can add character and individuality to rooms, no matter what their style.

"Ottomans come in so many shapes that you can easily find—or design—a style that is right for your purpose," said Hail. "And the correct size is up to your personal preference. Some people prefer an ottoman to be large and down-filled, others like a more discreet, tailored proportion. A three-foot-long tufted bench can be used in place of a coffee table. A narrow 12-inch-wide upholstered bench will fit beside a fireplace for easy seating."

Hail appreciates the mobility of ottomans and antique upholstered benches. "You can place them in front of windows where they'll fit neatly beneath the sill," he said. "You can also stand them beneath a console table in the hallway and bring them out for small gatherings or for your Monday night bridge group."

The size and weight of ottomans allows guests to take liberties with seating arrangements they would not take with larger, more formal furniture, Hail noted. Guests are comfortable picking up a bench or moving an ottoman to create new seating, whereas they would feel presumptuous moving an armchair.

"Draw it up to a sofa and beside an armchair so that several people can chat. Guests can easily join in the conversation around the ottoman. A bench or ottoman makes additional seating effortless."

Hail likes antique Gustavian-style Swedish benches that have arms on each side, or Queen Anne-style mahogany footstools. He's also partial to tufted ottomans with graceful legs, or ottomans upholstered in raw silk or chenille with tailored skirts.

"Antique—or almost antique—benches or footstools can transcend being simply functional and can become very decorative," he noted. "You can give them quite elaborate upholstery and trim them with tassels and silk braids."

OPPOSITE In this dramatic Northern California living room by Forrest Architects, Sonoma, a large ottoman is upholstered in painted canvas. Chairs by McGuire. Design: Jhoanne Loube.

Imaginatively designed ottomans, benches, and footstools can be the grace notes of a room. They can also be the most useful pieces of furniture, serving as tables, seating, props for clothing and books, and rest for weary feet.

SEASONAL Making seasonal fabric or color changes will refresh ottomans, change the look of a room, and enliven the decor. Consider dressing your living room ottoman with a beautifully tailored honey-colored cotton chenille or taupe wool twill slipcover in winter, and switching to a somewhat loose, more relaxed ivory washed-linen slipcover in the spring. Add ecru or white piping for extra zip.

EMBELLISH Upholster a footstool in remnants left over from other decorating projects or off-cuts in the remnant baskets of a fabric store. Or have an upholsterer cover the stool with salvaged corners of a worn-out kilim or dhurrie rug. Tapestry, too, gives a footstool or bench an elegant air — and it's very hardwearing.

ACCENTS Create a dash of frivolity for a serious room with a fringed and braided upholstered ottoman. For a formal, neutral-colored sitting room with chairs upholstered

in chenille, velvet, or silk, consider covering the ottoman in a vivid checked or striped silk trimmed with multi-colored corner tassels and silk braid. If the chairs are rather staid, give the ottoman or bench a down-filled tufted seat cushion outlined in colorful cord.

CASUAL For a family room, washable blue denim is very practical. (Polo Ralph Lauren even made a slipcover for an easy chair from old Levi's jeans — complete with pockets, button fly, waistband, and classic stitching.) Trim the square seat cushion of a large denim ottoman with yellow or red brush fringe. Line the inverted corner pleats with red-and-white or yellow-and-white gingham.

SPORTY For a sporty look, upholster a rustic iron-based bench or stool with a green-and-white or taupe-and-white awning-striped washable canvas. Trim the corners with inexpensive raffia tassels.

OUTDOOR For a sunny room, a pair of ottomans upholstered in fern leaf or other botanical print cotton could be piped in lime green or deep green. Have the chair or chaise longue pillows upholstered in plain off-white or taupe cotton so that the effect is not too busy.

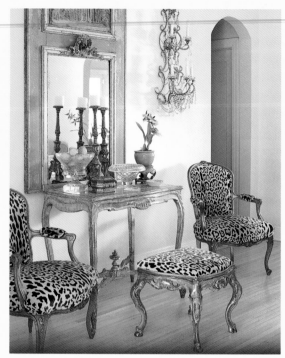

TERRY CLOTH Slipcover a narrow bench or small ottoman with washable cotton terry cloth. For extra color, add an ice-blue or taupe brush fringe and decorate the cushion top with mother-of-pearl buttons.

FUNCTIONAL For a living room that doubles as a library/study/home office, upholster or slipcover an ottoman in cotton printed with a book or map pattern. If the room is large, a large rectangular ottoman upholstered in dark green tapestry can hold books on one end and serve as a footrest on the other end.

MORNING ROOM In a sunny Arts & Crafts-style room, slipcover or upholster a bench in a two-tone taupe-and-beige-striped linen with a dark brown brush fringe around the seat cushion. Or upholster an ottoman with a deep green nubby cotton/linen blend fabric and pipe it in a mustard-colored cotton.

A B O V E Design can be playful, says Los Angeles antiques dealer/designer Melissa Deitz. Leopard skin upholstered gilded chairs and a curvy ottoman are styled for glamor and wit.

Hail doesn't believe these pieces should stand on ceremony. Upholstered antique benches are very multi-use and can be dragged from one room to another to substitute for a coffee table. In a bedroom, they'll hold a breakfast tray or a pile of Sunday newspapers.

Interior designer Ann Jones, who has offices in San Francisco and Sonoma in California's wine country (she's also a partner in the Sonoma antique store Sloan & Jones), said that ottomans and benches are the least intimidating pieces to choose and place in a room. They are almost interchangeable — benches and ottomans perform the same tasks — and there are no rules about sizes or styles that must be followed to be "correct."

"An ottoman or bench is usually at least 20 to 30 inches wide for comfort and versatility, but they can be as small as 16 inches square and still work well," said Jones. "A footstool, which you can keep under a coffee table or corner table, can be as low as 8 or 12 inches and be very useful."

They can be found in any price range. A vintage bench (in need of upholstery) could be purchased for as little as $50. An elaborately tufted suede ottoman with carved legs may cost $5,000.

Ottomans, footstools, and benches have become the chameleons of decorating. They can be elegant or casual, plain or fussy, antique or sleek, grand or modest, and in materials ranging from rattan and wicker to pine, aluminum, and mahogany. Fabrics

BELOW The great advantage of ottomans is that they are very portable. Move them closer as a perfect footrest. Even the Alvar Aalto stool can become an ottoman.

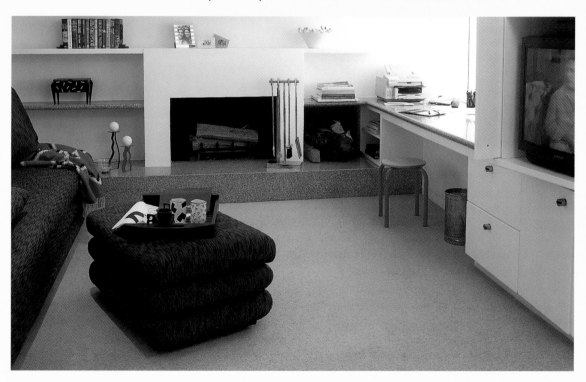

as diverse as silk velvet, suede, linen damask, leather, chenille, gingham, tapestry, and denim may be selected for upholstery.

Troy P. Walker, a San Francisco designer, likes round or hexagonal ottomans because they fit into many places in a room. "Two or more guests can sit around a 32-inch ottoman," said Walker. "And if the top is firmly tufted you can set a tray or magazines on it and it serves as a table."

Walker keeps two footstools in his living room. One, an antique, is upholstered in muted needlepoint. The other is upholstered with a colorful fragment of a worn-out kilim rug. "I use them as accessories rather than serious furniture," said Walker.

Elizabeth Dinkel, an interior designer who divides her time between her Russian Hill office and Los Angeles, likes to decorate with antique benches to bring elegance and style to a room without overshadowing the principal pieces of furniture. She'll use them in a window alcove, beside a sofa, or at the foot of an antique bed.

Jones said that an ottoman may match an armchair — or be covered in vintage fabric or a contrasting texture or color. She suggested that to be most practical, an ottoman probably should not be white or cream.

"Sometimes you forget to remove your shoes — or your dog or cat wants jumps up on the ottoman. It's better to upholster with a tightly woven fabric that can be cleaned, with leather, or with a washable denim."

Jones likes to work with "Putney," a heavyweight linen-like cotton fabric from Henry Calvin Fabrics. The cotton is dyed in versatile neutral and bold colors, is durable, and can be quilted to make the ottoman or bench cushion especially comfortable.

"Leather is more expensive than heavyweight cottons, but if you have young children or pets you can wipe away smears and smudges," said Jones. "Leather that has aged or is a bit worn is considered more attractive today than new leather, so don't worry too much about peanut butter sandwiches."

Elizabeth Dinkel likes to decorate with antique Louis XIV-style stools with the top upholstered in antiqued or printed leather with a nailhead trim around the seat. "My favorite seating arrangements are those clustered around a fireplace, and I always include a bench." antique stool, or an ottoman in the group," Dinkel said. "I like ottomans to be well proportioned and not overbearing for the decor."

Bigger is not necessarily better. "I'm not crazy for those oversized clover-shaped ottomans that look as if they belong in a Las Vegas hotel lobby," she said. "The trefoil configuration never looks right, and they're not comfortable to sit on or easy to move."

Interior designer Linda Floyd, who has offices in San Jose and San Francisco, said she thinks of an ottoman on casters as a "moveable feast."

She recently designed a tufted brown leather ottoman for a family room. With the addition of casters it can move around the room to be used as a work surface, a seat, a tea tray, or a coffee table.

Floyd also uses ottomans and benches as decorative accessories. "I designed a 36-inch diameter ottoman for a large bedroom in Hawaii," she said. "It's upholstered in colorful tapestry and trimmed with nailheads arranged in a scallop pattern. With lots of trim and beautiful fabrics, an ottoman can become a little jewel."

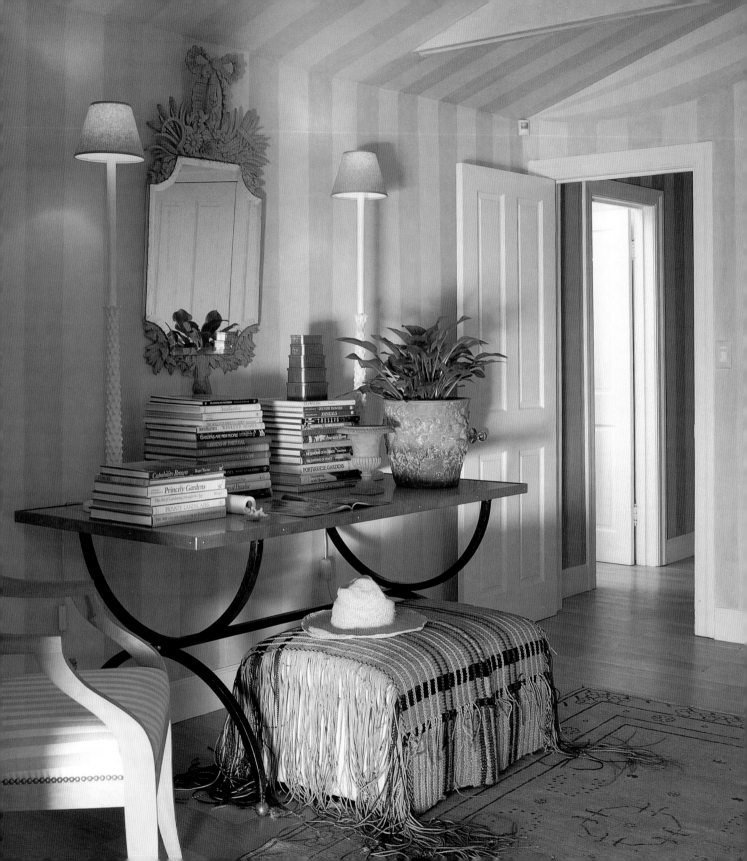

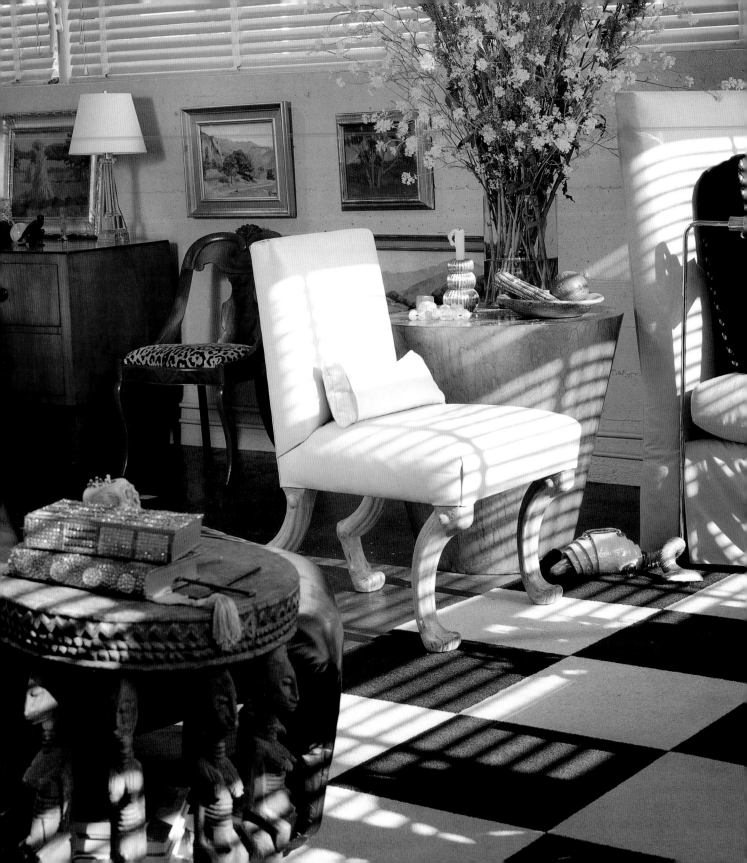

TABLES

With thousands of coffee tables and occasional tables to choose from, deciding on one or two can make anyone dither. A designer's tips will help.

Finding the perfect coffee table for your living room or family room can be one of the great challenges of decorating. This is one furniture purchase that must be both decorative, functional, and friendly.

Coffee table selection should not be intimidating. It is just good common sense rather than arcane decorating lore, said Belvedere interior designer Corinne Wiley. Possible choices range from a trio of rattan tables to original forties tables by Isamu Noguchi or the Eameses, or elegant Japanese-style lacquer tables. "There is never just one right choice, nor one exact size of coffee table you have to have," she said. "Many styles, shapes, heights, materials, and sizes of tables can be perfectly suitable for a living room or family room." The style you choose depends on whether you like to pile it with books, put your feet up on it, play card games on it, or use it to display paper weights and flowers.

Mixing room styles makes decor interesting, said Wiley. A clean-lined, silver-leafed contemporary Italian table is a provocative contrast in a somewhat somber traditional room. An antique Mexican table with the nicks and scratches of years of use adds texture to a pared-down modern interior.

Occasional tables are those reassuringly useful pieces that can do sterling service as lamp tables, side tables, coffee tables, sofa tables, end tables, hall tables, and card tables. They hold books, vases, small lamps, a newspaper, a glass of wine or a tray of drinks, or a coffee pot, and they have many decorative uses, too.

"Often the best occasional tables are those that lend themselves to double duty and can be moved and reconfigured in a room," said San Franciscan John Tobeler. "When you have guests, they're placed near chairs or the sofa and perform as drinks tables. When you're alone, you move them near you to hold your magazines or a cup of tea," Tobeler said. "I really don't have much regard for the very traditional tables that merely flank the ends of a sofa. That's too limiting."

Tobeler likes a variety of unexpected tables for their decorative impact, including McGuire's folding bamboo "Pinch Finger" table and Terry Hunziker's chunky, sculptural wood "Contoured Profile Table."

There are no design rules for occasional tables. They come in every material from simple brass or chrome to elaborately carved rosewood and craftsy fumed oak. They can be as small as twelve inches square to hold a candlestick, or long and narrow to back a sofa.

Some of the most interesting tables are improvised from flea market trophies. Yard sale and auction house treasures can always be worked on. Legs can be trimmed from a too-tall table, and good paint jobs can cover a million nicks and chips.

"A simple table of wood or bamboo can work in both traditional and contemporary rooms," noted Tobeler. "But I also like the element of surprise. Therien's 'Melon Taboret' has a gilt edge, a cinnabar lacquer, and a faux ivory top. It's a very glamorous piece, like jewelry in a room."

OPPOSITE Gary Hutton contrasted a classic John Dickinson chair with a carved African stool-turned–coffee table in his San Francisco studio.

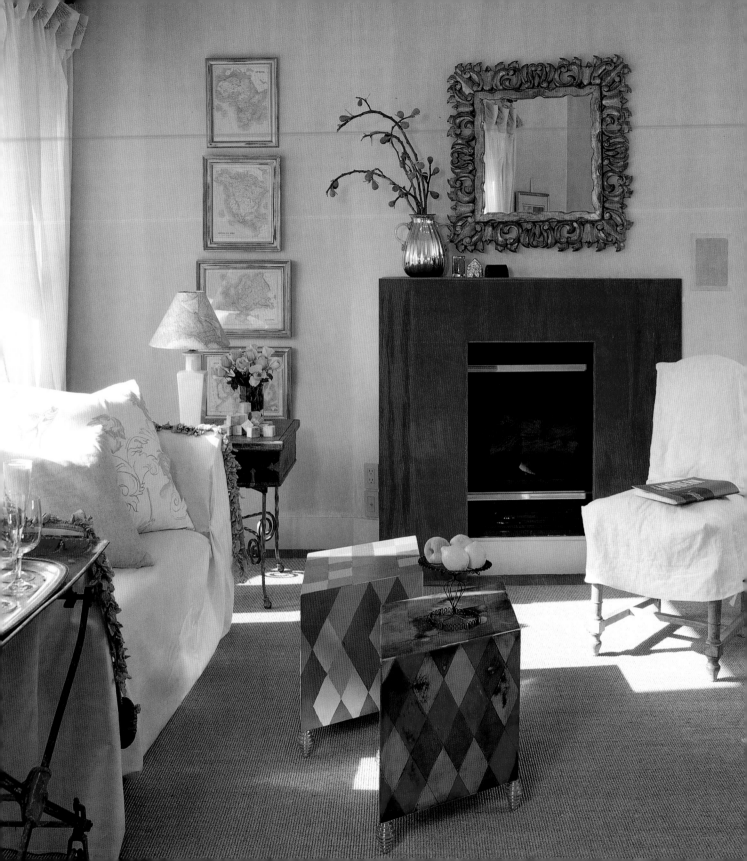

GLASS If you have young children or a boisterous family, avoid glass-topped coffee tables. They can be a hazard for youngsters and for parents concerned about spills and smudges. Toddlers can too easily topple and cut themselves on sharp edges. Glass-topped tables also require constant maintenance. Unless you're a fastidious housekeeper, a wood top would be preferable. Yet another reason to avoid a glass-topped coffee table: It will always have a rather cold, flinty look and will never gain character over the years. Seasoned interior designers seldom choose them.

SCOUT AROUND Search through your neighborhood antique shops, thrift shops, flea markets, and table stores for an old pine dining table. Have the legs shortened (for around $120) to coffee-table height. Paint, stain, or wax the table if it seems a little shabby. For a reasonable price, you will have a large, sturdy, practical, good-looking table.

IMPROVISE Learn to improvise. Old traveling trunks make useful coffee tables. Find them, along with old metal garden tables, Chinese lacquered trays, Japanese lacquered boxes, and chests at antique collectives and flea markets. Clean them carefully, but retain nicks, chips, and signs of age. They add character.

AUCTIONS Auctions are an excellent source for coffee tables or interesting bases — such as stone capitals — or garden tables that can be rescued for coffee tables. (Note: There is no such thing as an antique coffee table. And banish the thought of an authentic Louis XVI or Gustav III period coffee table. This is a modern convention.)

SIZE Be sure that the table is large enough for your purposes so that you don't have to clutter the top. Edit your collections and vases to perhaps a stack of books, a few magazines, candlesticks, and a loose arrangement of garden flowers.

SHAPE If you're short of space in front of the sofa, a small round or oval drum-shaped coffee table is the answer.

HEIGHT Remember that there is no standard height or size for coffee tables. The most useful height is between 17 and 19 inches, but lower or higher may work better.

FLEXIBILITY If you live in an apartment or want flexibility in your decor, don't select a massive table. Choose one medium-sized

table or two small ones that are easy to move.

STABILITY Wobbly, flimsy, or tippy tables do not function if you use the room often — or if you have pets or children. Be sure the table is stable and secure.

SCALE Avoid a bombastic coffee table that takes up all the space between sofas and chairs. It looks overbearing and unfriendly — and you're constantly walking around it.

VERSATILITY Do what elegant but practical English country houses have done forever: Use a wide uphol-stered stool as both coffee

table and extra seating. Top it with a broad silver or lacquered tray for drinks and glasses, and stack maga-zines or books on another corner. A flat, tufted stool is especially versatile and comfortable. You can even prop your feet on it.

ABOVE Berkeley designer Eleanor Moscow's antique table is perfectly poised — and practical. Small tables are always useful.

OPPOSITE "Harlequin" tables designed by Cheryl Riley add vibrant color to interior designer David Livingston's Telegraph Hill apartment. The tables can also be pushed together.

CERAMIC Colorful ceramic Chinese garden stools glazed in blue and white or bottle green can make versatile and inexpensive tables. (You can also top them with a cushion and use them for stools.)

CASTORS A new or antique table with casters can be moved around the room to serve as a tea table, an end table, or a coffee table. (You can always add casters to a new table. Find them at a hardware store or salvage yard.)

ECLECTIC While some designers like to have end tables or sofa tables matching, it is often more interesting to find tables with different styles. For example, a simple round new table could stand on one end of a sofa, and an antique desk-style table could be positioned at the other end. Mismatching small tables can be used in front of the sofa in place of a large coffee table. This is especially effective in a small room in which a big coffee table can become an annoying hurdle.

STORAGE Occasional tables can often act as storage. Look for tables with shelves or drawers.

CREATE Make an occasional table from a butler's tray or a vintage marquetry tray set on a new stand.

ABOVE Practical and dramatic: coffee table design makes a statement in this Los Angeles room.

OPPOSITE Modern and movable: Alvar Aalto birchstools, available through New York's Museum of Modern Art, make useful tables in Jonathan Straley's loft.

San Francisco interior designer Arnelle Kase, admired for her finely detailed work, believes that occasional tables should be inventive, full of character, and not mere wallflowers.

"I often custom design a table or two for a living room to give a feeling of true individuality," said Kase. "It may be quite modest but crafted in beautiful wood or painted in an unusual color. Often the table has a quirky shape to the leg, or a mismatched top. That's the finishing touch a room needs."

Arnelle finds some of her best tables in San Francisco's Chinatown. "You don't have to spend a lot of money on a table," said Kase. "Along the Chinatown streets, such as Grant Avenue and Broadway, there are big ceramic garden seats both round and square. Many have traditional floral designs but others are in subdued celadon glazes, brown, or white. They're very practical indoors, won't scratch or stain, and come in a great array of unusual colors. Some of them cost as little as $20 or $30."

Traveling trunks, storage chests, small tansus, and old drums can also make great stand-ins for coffee tables. And always make interesting tablescapes on your coffee table—let imagination guide you.

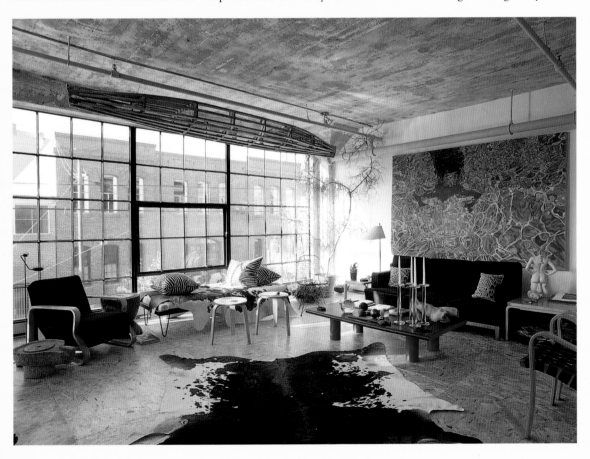

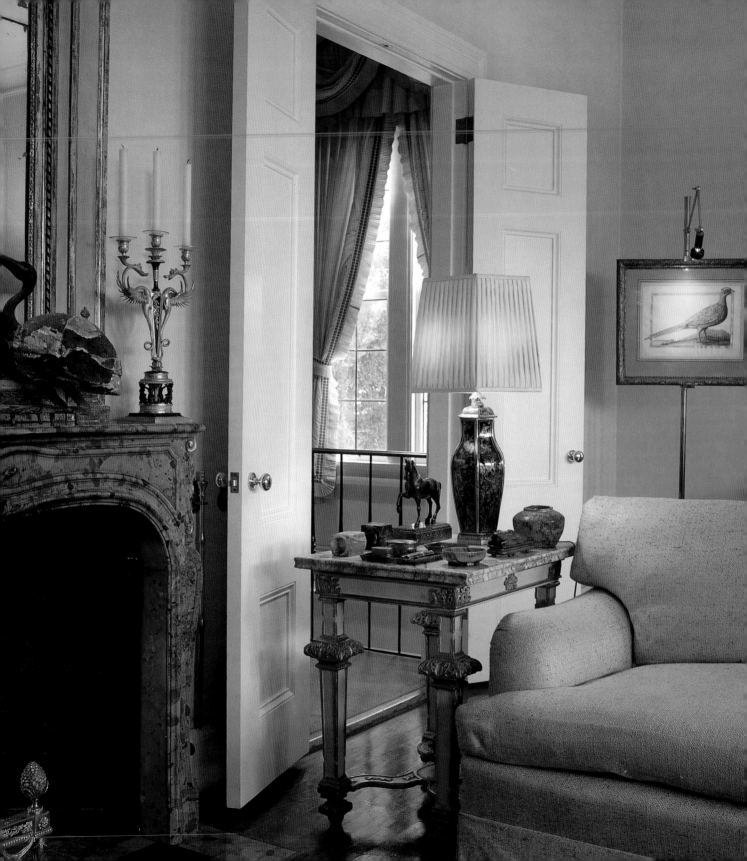

LIGHTING

The best lighting is functional, uplifting, decorative. Consider mixing hypermodern lamps with traditional decor, antiques in modern rooms.

San Francisco interior designer Orlando Diaz-Azcuy is very opinionated about table lamps.

"Many people see table lamps as a mere afterthought instead of as an integral part of room design and function," said Diaz-Azcuy, who designs international hotel interiors, in addition to residences and furniture.

"Table lamps should offer a warm, friendly illumination, and their design should be versatile," said the designer. "They can offer both ambient and specific task lighting. They should not just be something you bring in only after the rest of the room is pulled together."

Orlando Diaz-Azcuy believes that table lamps should be chosen at the same time other furniture is selected.

"When you buy a bed, a table, an armchair, or a sofa, you should also be considering which lamp will stand near the sofa or on the bedside table, and which table lamp you need for reading," he said.

"Every room—not just the living room, but also the hallway, the bedrooms, and even the family room, study, or home office—can benefit from well-designed table lamps," Diaz-Azcuy said. He recommends investigating several lighting stores, showrooms, and furniture shops to see what is available.

"Getting the proportion, the color, the shade, or the style of the base just right can be very tricky," admitted the designer. "A dramatic lamp can be very seductive, but I always recommend keeping the design simple. It's best not to be too rigid with design 'rules.' If you follow a few basic guidelines of proportion—and trust your eye and judgment—you should find a lamp you can live with for many years."

"For example," said Diaz-Azcuy, "the average living room measuring approximately 12 feet by 14 feet can take one or two slender table lamps as tall as 26 or 30 inches, including the shade, if the bases are graceful. Bigger rooms call for grander lamps."

"If you want to make a design statement, and you have a large room with a high ceiling, your table lamp could be as tall as 36 inches overall," noted the designer. "A lamp over 30 inches tall needs to be balanced with a grand sofa at least nine feet long, as well as large paintings, a substantial refectory table or a 42-inch-diameter skirted table. Otherwise, everything in the room is dwarfed by the large lamps."

The designer said that there are no hard and fast rules for lamp size, but the bulk and silhouette of the lamp should never overwhelm the size and style of the table on which it stands. Conversely, the lamp should not be so small that it is dwarfed by the table and adjacent plants or stacks of books.

"There should be space on the table beside the lamp for sculptures, flowers, and framed photographs," he said. "The proportions of the lamp and tabletop should be taken into consideration along with the whole tablescape."

The designer believes that understated lamp design is usually best. A plain off-white urn-shaped plaster lamp, a graceful chrome column lamp, or a

OPPOSITE In his San Francisco living room, Anthony Hail prefers lamps with antique bases and silk shades. Their essence: grace and uncomplicated style.

brass swing-arm lamp will not date. A well-designed but unobtrusive classic lamp can be used for decades, moving from room to room, or from a starter apartment to a new house.

"I would never buy a lamp that called attention to itself unless it was extremely beautiful, handcrafted, or rare," said the designer. "If you want pattern, use it on pillows or arrange a vase of colorful flowers. A lamp cannot carry the whole design statement." The last thing you should notice is the design of table lamps.

"Lamp bases, whether they're antique or the newest Italian designs, should be the simplest possible shapes and they should be primarily a source of light, not decoration," he said. "Unless it's a fine antique Chinese base, an outstanding sculptural base, or a very beautifully crafted antique base, it's best to buy a very plain, elegant lamp and avoid anything too trendy."

Most rooms need more than one table lamp. "When a living room is lit solely by table lamps, you should have several lamps with the 'pools' of light overlapping," he said. "Your eyes have to have a sense of fairly even lighting without hot spots or dark shadows. One of the lamps would most likely be adjustable so that you can shine it toward your book, onto a painting, or across a desktop. You should be able to direct the light where you will be reading or writing."

While matched pairs of lamps can give a room symmetry and balance, Diaz-Azcuy prefers to have a well-edited collection of two or three different lamps in a living room, or an unmatched pair in a bedroom.

"Perhaps if I had a pair of matched tables or chests, I might place matching lamps on them, but otherwise the style and shades should not all be consistent," he said. "Each lamp should have its own individual style."

Repetition is not always desirable. "When you have three or four of the same lamp design in a room, it starts to look like a hotel lobby," said the designer. "It's best to choose lamps that are suited to specific places in a room. A classic column-based lamp that's the correct size on a mantel will probably look too small on a console table beneath a gilded mirror. A handsome terra-cotta-based lamp that works well on an antique table beside a large traditional sofa might be overbearing on a smaller table next to an arm chair."

Getting the mix right is important. One sleek contemporary lamp can add grace and freshness to a somewhat sedate traditional room. Two chrome Italian lamps in the same room might look a bit too edgy and insistent. Similarly, said the designer, a series of very "correct" matching lamps with porcelain bases and ruffled silk shades can make an English-style city apartment living room look prissy and uptight. One unexpected lamp, such as a Jean-Michel Frank–style white plaster lamp or an antique hand-painted tin lamp in a modern study can create character and individuality.

ABOVE Design for dollars: David Livingston improvised a lampshade with a map and a few hours of careful cutting and pasting. The base is a flea market ceramic.

OPPOSITE In his San Francisco apartment, antiques dealer Conor Fennessy has a rotating display of fine objects. His quirky metal lamp suits the mood.

ECLECTIC All table lamps in your living room do not have to match. A properly lit room should have at least three different light sources, but the table lamps can be of different styles, heights, or materials. For example, an urn-shaped white plaster table lamp would be at home in a living room with an antique gilded column lamp or a contemporary chrome-based lamp.

SIMPLICITY Avoid fussy, overdone, and brightly colored shades that look like party hats. They add visual clutter to a room and can look very dated. Instead, look for classic silk, linen, frosted glass or paper shades without the frou-frou. For Arts & Crafts-style bases, handcrafted shades in opaque paper are fine.

PROPORTION Be sure that the shade is correctly proportioned for the base. It must be large enough to conceal the bulb and the metal socket, but it should not overwhelm the lamp. The top circumference of the shade should be at least 1 1/2 or 2 times the width of the base.

FINIALS Choose a finial that enhances and adds style to the lamp. For example, a Chinese porcelain lamp would look sophisticated with a jade finial. For table lamps in a beach house, shell finials are a very attractive flourish.

OPACITY Always check the opacity of shades. Thick paper shades will direct pools of light up and down and will probably give less ambient light.

STYLES For a living room decorated in an eclectic style, consider mixing contemporary table lamp designs — such as a Noguchi paper lamp or a clean-lined frosted glass Italian design — with a classic white plaster or porcelain urn-shaped lamp. When disparate designs are all white, the effect is harmonious, not higgledy-piggledy. Similarly, several styles of brass lamps or painted tin lamps would work together.

SCOUT AROUND Flea markets and junk shops are often a great source for vintage lamps. Fifties, thirties, and Victorian lamps may need new shades or rewiring, but their authenticity adds substance to a living room.

FUNCTIONAL Be sure that your lamps balance function and decoration. A lamp should look beautiful, but it must also work well for its particular task. For a writing desk, one excellent choice is an adjustable lamp, such as the contemporary classic "Tizio," or a simple gooseneck lamp whose height and direction are adjustable.

DIMMERS Put all your table lamps on dimmers rather than three-way switches. For a small cost, you'll have adjustable lighting and the ability to change the mood and lighting in rooms.

BASIC When in doubt, use a plain, simple monochromatic base and a plain off-white linen shade.

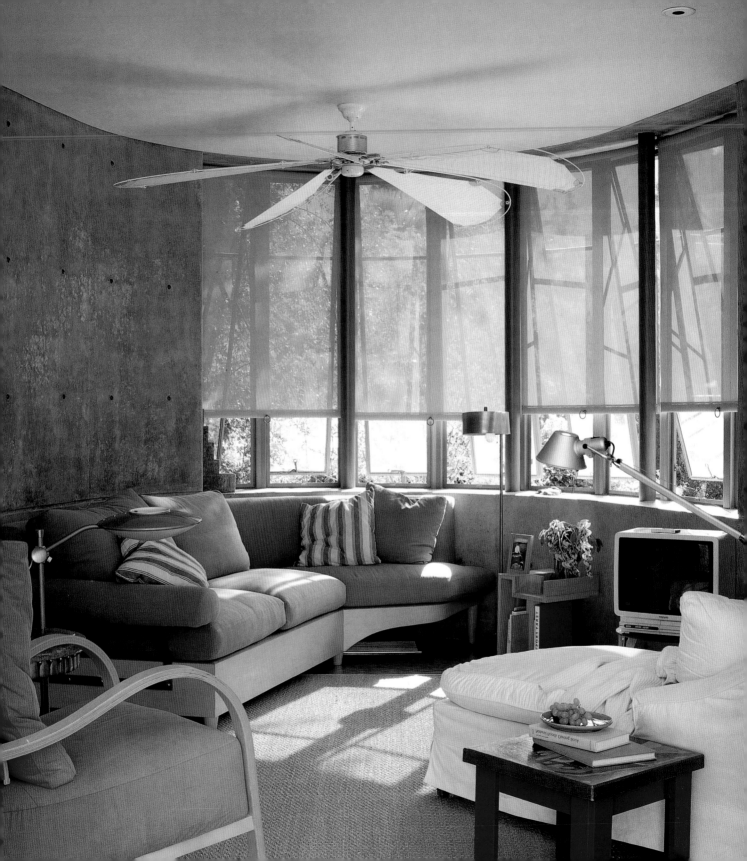

Artful lighting can draw attention to beautiful "moments" in the interior design of a living room, and cast less-than-perfect features into oblivion.

Getting lighting right may take experimentation — or a visit from a professional. Be imaginative, be patient, and one day the simple flick of a switch will bring a nighttime room to life.

CAPRICE DE BEAUX-CARTER, lighting consultant at Limn Furniture, San Francisco, offers these lighting tips.

LAYERING "Layering" lighting makes a room much more functional and interesting. Choose two or three different sources of light. In a large living room, an overhead chandelier, a table lamp, or a torchère — all on dimmers — could be chosen to give the room character, multiple moods, and variable light.

COLOR Hand-blown glass light shades in tones like amber, cream, peach, or red are flattering. Clear blue or green glass tends to make a room feel cold. Zinc Details in San Francisco has hand-blown glass shades, which can also be custom-ordered.

GENERAL Take care of general illumination first. While one bright overhead light may be practical and necessary

in a kitchen, it's probably too harsh in a living room. For most rooms, the appropriate combination of torchère, wall sconces, reading lights, table lights, or pendant fixtures provide more useful, versatile, and appropriate lighting. A pendant fixture plus a table light offers basic, general lighting for most rooms.

ACCENT Consider accent lighting to highlight art objects, paintings, or flowers in an entry hall. Choices include recessed lighting, informal track lighting, low-voltage lights, or low-voltage cable wire systems. Individual mono-point lights are easy to install. Small, portable plug-in accent lights, can be concealed behind furniture.

TASKS Always take specific tasks into consideration when planning lighting. Halogen desk lights, vanity lighting, floor reading lights, flexible under-cabinet lights, and decorative table lamps put the best light right where you need it.

DECORATIVE When your basic lighting needs are planned, look for small, decorative accent table lamps. The classic paper-shaded "Akari" light by Isamu Noguchi, innovative lighting designs by Ingo Maurer, San Francisco's Michael McEwan, and Andree Putman's elegant Ecart collec-

tion are excellent choices for warm, ambient lighting.

ENERGY Improved technology for more convenient lighting includes handheld remote controls for dimmer systems; pre-sets that adjust one room or the whole house to different lighting moods; energy-saving lamps; compact, color-improved fluorescent lamps; versatile energy-efficient screw-in fluorescent lamps.

HALOGEN It's a crisp, sharp light and perfect for task and accent lighting.

CANDLES Candles can be a romantic source of lighting.

BELOW A curvy lamp by Goodman Charlton. (Interior design: Michael Berman.)

OPPOSITE Lamps don't have to match. This assortment works well. (Architecture by Kuth/Ranieri.)

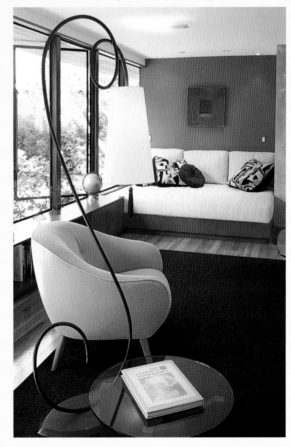

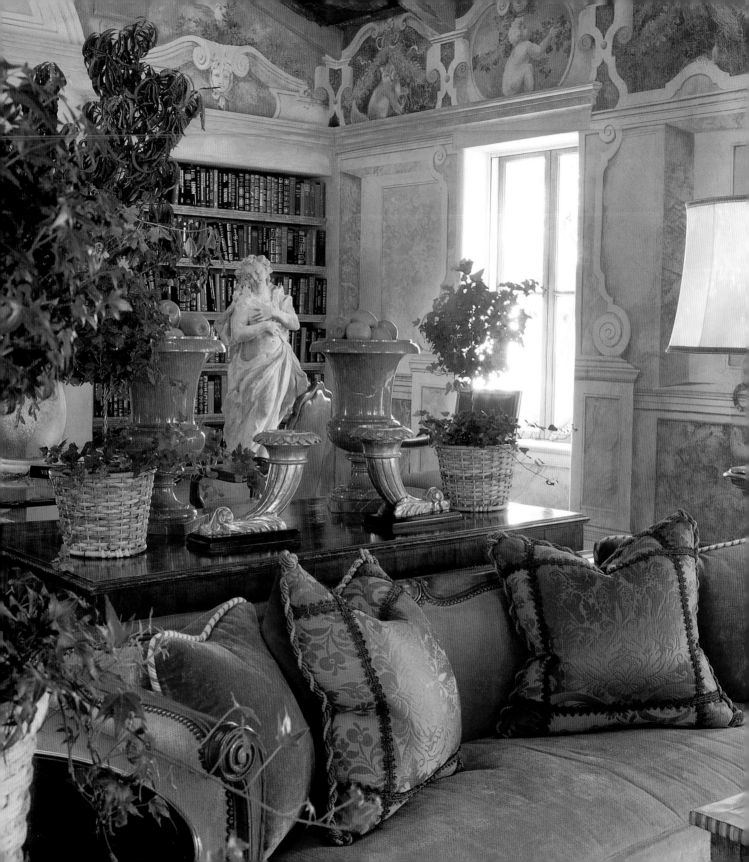

TRIMS: ICING ON THE CAKE

Trims, cords, gimps, braids, tassels, and fringes
add texture and charm to interior decor.

Trims are an easy way to add personality to interiors. Beautiful trims on classic tailored linen or basic cotton upholstery fabrics have the same pleasing effect as jewelry on a little black dress. The classic chair arm with an added multi-colored silk cord piping goes from mundane to eye-catching. A luscious looped fringe or flouncy tassel on a club chair or sofa takes the furniture from sedate to stylish.

A cotton velvet or natural linen pillow will look much more interesting crisscrossed with textured ribbon. A basic taupe washed-linen slipcovered sofa gains new pizzazz with black or navy cord piping or an off-white cotton bullion-fringe skirt.

Multi-colored fringes and grosgrain ribbons in imaginative colors make store-bought draperies and pillows special. Trims also add elegance to today's relaxed decor. A tapestry-pattern braid, silk cord, or chenille fringe on a pillow or drapery adds richness without adding a lot of pattern.

Trims are also a very frugal way to add flair to listless or dated decorating. A washed-linen slipcover or beige damask draperies trimmed with a simple $2-per-yard rope cord or a $5-per-yard cotton fringe in a contrast color quickly look updated and stylish.

Fringe Benefits

Cords are the easiest trims to start with. Ivory, taupe, ecru, or natural cords always look right along the edge of a pillow. A narrow twisted silk cord in ivory can look very refined outlining a taupe linen pillow. A larger-scale natural-cotton rope cord will give a white

or taupe-and-white striped linen slipcovered headboard a new attitude.

Natural-fiber tassels, braids, cords, and fringes look fresh and simple and more relaxed in California houses. However, for a Victorian parlor or forties living room, more formal trims — true-to-the-period trims — may be more appropriate.

A fine way to introduce silk tassels or luxurious metallic or chenille fringes is to add them to small silk or tapestry pillows. They'll look rich without seeming overdone or fussy.

Spiff up an old sofa with a fringe in heavy bullion or delicate silk.

Creative Solutions

Fringes on pillows, twisted cords edging draperies, and tassels add vivid embellishment to upholstery in quiet hues or subdued patterns.

Plain cotton or washed-denim draperies outlined with an embroidered braid in a contrast color, or edged with a flourish of twisted cord in colorful counterpoint, suddenly have all the glamour of a ballgown. Still, unlike bold patterns, the trims do not overtake the room.

While most designers and home decorators would be more than content outlining draperies and pillows with braids, cords, and tassel fringes, the more adventurous also see the possibilities of edging a tablecloth with bullion fringe, outlining a decorative screen or wall panel with gimp, finishing a roll pillow

OPPOSITE Napa Valley interior designer Thomas Bartlett used custom-dyed trims in this Italianate country living room.

with a silken rosette, and adorning a linen headboard or cotton Roman shade with jute or natural cotton tapes or cords.

Trims can also be used to embellish lampshades. While trim novices may want to start with natural, beige or white cotton, jute or wool fringes or braids, the more adventurous will be attracted to tassels and tiebacks in hues like mustard, teal, periwinkle, celadon, chrome yellow, cerulean, and Coca-Cola red.

From graceful silk drapery tiebacks, colorful looped fringe tablecloth edging, or chenille bullion fringe, the enthusiastic trimmer will want to move on to pillow tassels, ottoman edging, and perhaps ivory cording on a lamp shade. Tassels and gimps can be very seductive, so you have to know when to stop. When cords or fringes are very fussed-over or too complicated, a room can feel very uptight and studied. Elaborate fringed draperies with tassels and corded silk tiebacks may look gorgeous in a city apartment bedroom, but too Scarlett O'Hara and over-the-top in the suburbs.

Experienced designers prefer gutsy fringes and cords in simple materials like cotton, linen, or wool, and avoid pretentious, tiny, skimpy, or fussy trims.

Trim Glossary

Braids: (Also called galloons.) Flat woven textiles up to three or four inches wide, used to edge curtains, add texture to pillows, or outline skirts of chair or sofa slipcovers. Scroll braids add character to bed linens, table skirts, and valances.

Borders: Flat, woven ribbon-like textiles up to six inches wide. Traditional-style borders — usually with elaborate decorative motifs — are used to add color, pattern, and texture to ottomans, dust ruffles, draperies, upholstery, pillows, and valances.

Cords: Inexpensive lengths of rope-like, twisted yarns with a multitude of decorative uses, from edging pillows to piping a silk-upholstered ottoman. Cords can be plain, plaited, multi-colored, or elaborately intertwined, and made in silk, rayon, cotton, synthetic fibers, linen, or natural jute.

Fringe: Available in a wide range of styles and widths from one to twelve inches. Brush or moss fringes are short, full, brush-like cut fringes used for outlining a pillow or draperies. Tassel fringes — trimmed with mini-tassels — add glamour and texture to pillow draperies, sofa skirts, and table skirts. Bullion fringes, often used instead of a fabric skirt on a sofa, are made of six- to eight-inch-long thick, twisted cords attached to a braid edging. Fringes can be delicate or gutsy in size. Osborne & Little has an unusual new line featuring luxurious chenille bullion fringe. Attached to

the skirt of a sofa or chair, it protects furniture from shoe-scuffs. At the other end of the fringe spectrum, delicate beaded fringe may be used to edge a lamp shade or silk draperies.

Gimp: A simple narrow braid or cord ribbon, functional rather than decorative, used to conceal tacks on sofa and chair upholstery, or staples on wall panels.

Passementerie: Refers to the whole range of trims — from simple gimps and borders to elaborate tufts, tassels, rosettes, and tiebacks. Particularly used to describe highly detailed trims like those handcrafted by Scalamandré.

Rosettes: Flower-like tufts of silk or rayon at each end of a bolster pillow or on the corners of curtains

or pillows. Also used to finish the rolled arm of an upholstered sofa or chair.

Tassels: Drapery and upholstery ornaments consisting of a bell-shaped header and a length of cut yarn. Also used to embellish window shades, corners of pillows, valances, basic fringing, or armoire keys. Tassels are usually combined with ropes and cords to form tiebacks, stair rails, chair pillow ties, key tassels, and rail ropes.

Tiebacks: Decorative cords and elaborate braids hold drapery in position.

OPPOSITE Custom-colored trim by designer Paul Wiseman.

BELOW Trims are used with great sublety in this elegant San Francisco living room. Design Patrick Wade and Stephen Brady.

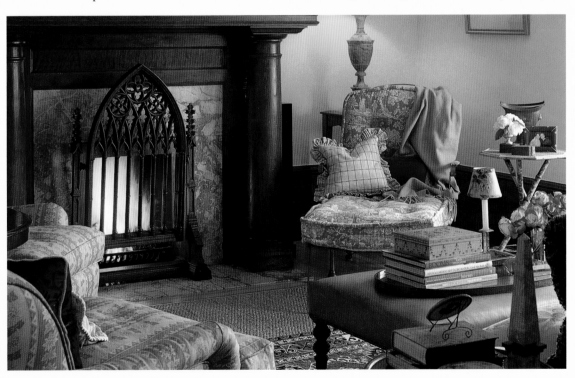

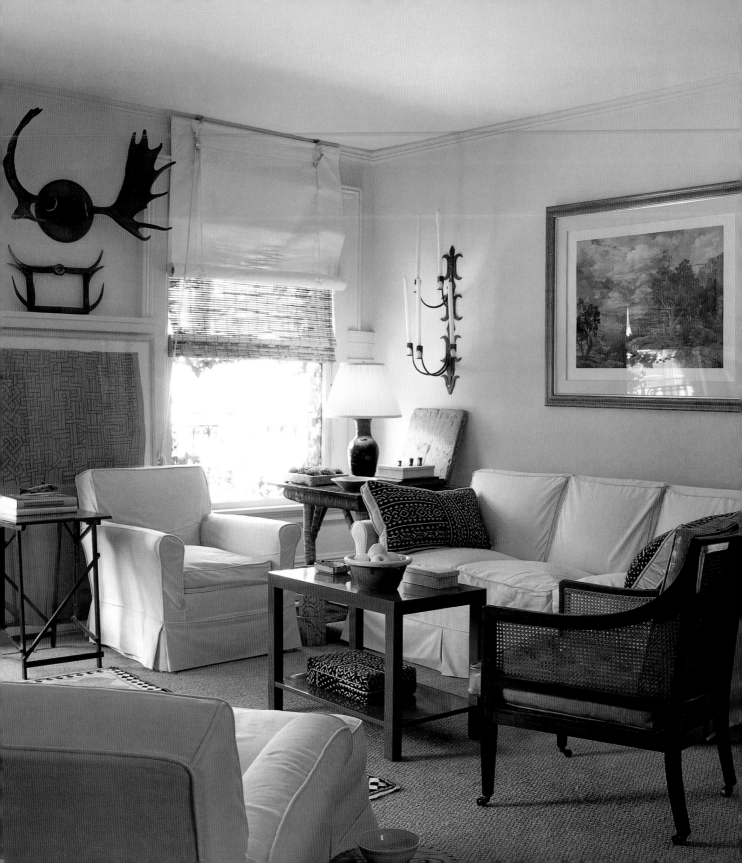

ACCESSORIES

There are no rules for best placement or selection of accessories. Follow your heart. Light touch or edited clutter, display's the thing.

Light a handmade beeswax candle in your funky gold-dipped candlestick. Draw up your favorite Louis XVI-style or Gustavian chair to a cool new steel table, and breathe a sigh of relief. There's a liberating new please-yourself attitude in home accessories. The tyranny of the status object is over.

Accessories now celebrate individuality, quiet beauty, and sometimes a hip, street-smart style. You can put a witty new wire basket full of Granny Smith apples on your family heirloom table. You can light a silvery wire lamp beside a terra cotta pot of narcissus. Urbane style can coexist happily with rustic elegance.

Old so-called rules of decorating no longer apply, so don't worry about getting it "wrong." Modern moved in with Arts & Crafts. Biedermeier shimmies with Anglo-Irish. British Colonial has a certain affinity with early Chinese and Japanese furniture — even Mexican Colonial. And what could be prettier than a Louise XVI-style chair and a Gustav III chair (repro or real) doing a sedate gavotte with a pretty Welsh pine chair with a natural linen cushion?

Nature offers up beauty for the finding. One dried magnolia leaf could look as exquisite as a fine hinoki-wood carving laid on top of a foxed first edition of Colette's poems. Roadside nasturtiums, callas, fennel heads, Osage oranges, or eucalyptus branches are cheerful, fragrant, and secretly thrilling.

Contrast is always intriguing, but a tablescape composed only of white objects — a plaster lamp, porcelain bowls, *blanc-de-chine* vases, beach-bleached shells, and 'Iceberg' roses in a Sevres vase—would not be at all boring.

Beauty today can be seen in silk velvet, cashmere, and Irish linen — or in gauzy cotton, cotton canvas, even burlap if it's carefully sewn and draped. Accessories don't have to impress with over-the-top glamour, rarity or a high price tag. Now accessories can be rather humble materials and be quite understated. The surprise of an old gilt mirror at a beach house — or "off" mixes of colors, slightly-unsettling prints, industrial objects, or salvage-yard discoveries in a city apartment — can make rooms memorable.

Don't look for just one design icon, one single must-have glass vase, articulated lamp, aluminum bowl, or whistling tea kettle to make your whole design statement. Now, kitsch and glamour meet. Old and worn objects are pleasing to the eye. And basic is always beautiful. Just do it with style. Above all, enjoy and luxuriate in pleasing your eye and your heart with accessories that have meaning.

ABOVE The best collections are accumulated over years of fortuitous finds and happy foraging. Here, Arnelle Kase's colorful gathering of Eastern European glass and French mercury glass — found all over the world. Colors are quirky, the effect pleasing.

OPPOSITE In Michael Tedrick's polished but perfectly pleasing studio, he created a harmonious composition of chairs, a Chinese lacquered table, and a folding campaign table. Accessories don't scream, rather they are introduced with a light hand.

VIRTUOSO VASES

**Old and unusual vases can enhance your favorite flowers. Keep a varied
selection on hand, and always keep arrangements straightforward.**

For a few confident and fortunate souls, arranging flowers in a vase is pure pleasure. The flowers seem to smile back. But for many gardeners and flower lovers, creating bouquets that look beautiful is a thorny mystery.

"The secret to memorable arranging is to choose a vase in the right shape for your flowers and never to fuss with your blooms," said Jean Thompson, co-owner of Fioridella, the 17-year-old San Francisco flower shop.

The right vase, which can be as simple as a glass cylinder, will hold blooms with grace and enhance their beauty without stealing the spotlight. Flowers should look loosely arranged, not stiff and tortured. "It's important to select a vase that's appropriate in size and style for your flowers," said Patric Powell, owner of Bloomers, a favorite San Francisco flower shop.

"The classic rule of thumb for proportion and size is that the height of the flowers above the rim of the vase should be at least one and a half times the height of the container," said Powell. "I don't always stick to that rule, but it's a good starting point."

For example, he said, for a bouquet of eight to a dozen stems of elegant Casablanca lilies about 30 inches long, the urn-shaped glass vase should be about 12 inches high. If stems seem to bend easily, the neck of the vase should be quite narrow. The vase should support and show off the lilies well.

Powell said he likes round or urn-shaped glass vases about six or eight inches high for shorter stems of roses, anemones, tulips, or freesias because full bouquets of flowers fan out nicely.

Natural Arrangements

Another secret to flower arranging is to keep flowers looking their natural best. An elaborate florist arrangement is wonderful — from an experienced florist.

Delicate mauve Siberian iris that look gorgeous in the garden need only a simple tall glass cylinder vase to display their beauty indoors. A small trumpet-shaped crystal or ceramic vase will hold a bunch of fragrant pink 'Fantin Latour' roses in a very pleasing, unforced arrangement. And a tall, narrow bottle-shaped vase is perfect for a few dramatic stems of lisianthus, poppies or French tulips, said Jean Thompson.

Simple, elegant arrangements don't need fern, babies breath, or any extra foliage.

"I always say, 'Keep it simple,'" said Thompson, who generally favors subtle white and pink flowers over gaudy orange or red blooms.

"Instead of cutting or buying many different kinds of blooms, choose two or three bunches of one kind," she said. "Just pale cream tulips, white and green ranunculus, or blush-pink garden roses will stand out on your dining table or mantel and bring understated color to your room. Calla lilies' naked stems might need an interesting leaf or a grass."

To make arranging easy, Thompson suggests grasping the bunch of flowers in your hand, removing the rubber bands, trimming an inch or two of the stems, then placing the stems all at once in the prepared vase. "This way, the flowers arrange themselves,"

O P P O S I T E Jean Thompson sets tulips and garden roses in dramatic handblown Mexican vases. Her advice, don't get complicated.

she said. "It's so much more successful than putting them in one by one and forcing and fussing."

In her own living room, Thompson prefers to have five or six stems of scented rubrum lilies, French tulips, sunflowers, or calla lilies in three or four glass or silver vases of different heights.

Rosemary and Roses

Garden designer Sarah Hammond keeps a collection of vintage and new containers ready for bouquets she gathers at dawn in her Marin County garden. In Hammond's confident hands, a tall arrangement of upright rosemary and old-fashioned 'Mme Plantier' white roses stand handsomely in a reflective galvanized-tin French florist bucket.

On Hammond's pine dining table a pair of delicate round Smith & Hawken crystal vases just four and six inches high display two heads of ruffled pink old-fashioned roses with a stalk or two each of purple salvia, graceful white *Omphalodes linifolius*, or blue/mauve nepeta (catmint).

"I don't like anything too ornate to hold my flowers," said Hammond, who returns from her annual trips to England on horticultural business with vintage white stoneware pitchers in timeless shapes.

"It's the flowers that matter most, so the container should not be too obtrusive," Hammond said. "One wants to reveal the beauty and form of the flowers. The blooms and their leaves should always predominate."

Simple Concepts

Alta Tingle, owner of The Gardener, a 16-year-old garden-style store in Berkeley, chooses brown-toned, bronze, green ceramic, and glass vases for her flowers. "Natural browns and greens are a great complement to green leaves and flowers," said Tingle, who prefers to arrange flowers of the same species in her vases.

"I'm not a great flower arranger, so I choose simply a handful of vivid poppies from my garden or lilac or daffodils. Then I can't fail." Tingle's bravura arrangements of flowering branches, ornamental grasses, and colorful seasonal wildflowers suggest that she is an expert arranger. In her hands, a few callas standing in a tall square glass vase, or a branch of plum blossom in a cylinder of Mexican recycled green glass is extremely affecting.

Versatile Vases

Claire Marie Johnston, a floral designer in Pacific Heights, San Francisco, suggests that even humble flowers like daisies, geraniums, and pansies look elegant when massed together in a collection of glass or vintage vases. Her company, Flowers Claire Marie, is popular for natural and elegant wedding and at-home flower arrangements.

"A simple thick clear-glass cylinder about 20 inches high is versatile for holding tulips, lilies, delphiniums, flowering branches, and even wildflowers," said Johnston. "In this kind of holder, you can do both simple and more elaborate arrangements."

ABOVE Fresh charm: Jean Thompson's quick arrangement of spring tulips was placed directly into an oval-shaped galvanized metal bucket.

OPPOSITE Often, seasonal branches of fruit, berries, or pods can make a pleasing arrangement in a glass cylinder vase. Here, in Susie Buell's apartment, fresh figs look sculptural.

Green-glass urn-shaped vases, silver mint julep cups, and glass bud vases are perfect for holding small flowers at the center of a dining table, she said.

"A tablescape of different vases makes an interesting change from the usual centerpiece on the table," Johnston said. "Long-necked glass vases, angular vases, inexpensive three- or four-inch cylinder glass vases will hold hyacinths, lilies of the valley, miniature roses, and anemones. Keep them low so that your dinner guests can see over them. Votive candles in glass holders add a beautiful glow."

Above all, be guided by the flowers. "Bright orange poppies or pale pink garden roses are breathtaking," Johnston said. "Set them in a glass vase, keep the water refreshed, then enjoy them for days. Fresh flowers indoors give your spirit such a lift."

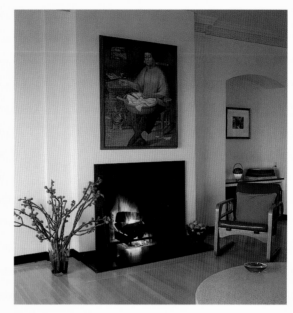

MAKING ARRANGEMENTS

SIZE Start with a vase that's the right size—not too tall and not too wide. Fill it with lots of fresh water. You might try old tricks like adding a few drops of bleach (to keep the water fresh), an aspirin (possibly to add longevity), a spoon of sugar (to "feed" the flowers), or a dash of vodka or boiling water (allegedly to encourage flowers to open faster). Flower "food" products like Floralife (from florists) can also help flowers last longer.

INFORMAL Aim for a natural, unforced look. A rather artless, country arrangement that doesn't look too "done" or worked-on is best today. Flowers in the vase shouldn't look too symmetrical. The tortured eighties look of stiff stems and pretentious vases is out.

IMPROVISE Improvise a "vase" from an old pottery pitcher, a silver bowl, a vintage glass jar (for geraniums, roses, or grape hyacinths), an antique medicine bottle (for daphne or jasmine from your garden), or empty champagne or wine bottles (perfect for a few tall poppies). A lidless teapot, a wine glass, a glass block, or an antique silver trophy cup make splendid flower containers.

MINIMAL Sometimes, just a few stems of beautiful flowers are all you need. You don't have to create an "arrangement" every time. Fern and babies' breath as "fillers" look rather dated and unnecessary. Let the flowers shine without much extra foliage. Always trim away leaves on the flower stem so that there are no leaves in the container—they will cloud the water.

SIMPLICITY Monochromatic collections—a handful of pink poppies, a few white roses, or a handsome stand of sunflowers—don't need any arranging. Place them in the right vase and don't fuss with them.

SELECTION When choosing flowers from the florist, look for unopened buds and flowers that are not yet at their peak. They will last longer, and you can enjoy the whole cycle of the flowers' blooming.

EXPRESSIVE Develop a personal style of flower arranging. If you love big full bouquets in cloisonné vases on your mantel, that should be your pleasure. If you prefer sweet little collections of baby pink 'Cécile Brunner' roses or single Casablanca lilies on your bedside table, make them your signature.

NATURAL While chicken wire, metal pin holders, glass marbles, bamboo sticks, and other arranging aids can be useful, try to arrange without them. The finished flowers will look more natural and effortless.

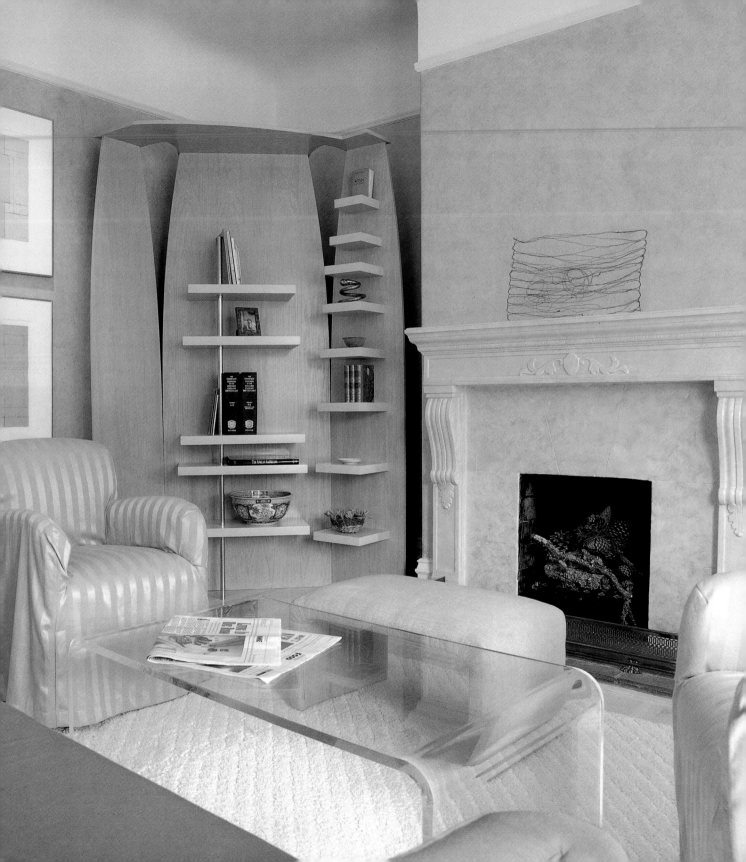

LEARN FROM THE DESIGNER

Designers finesse fabrics, upholstery, draperies, floor materials, and other design challenges every day. Gary Hutton shares his experience, knowledge.

San Francisco designer Gary Hutton has been designing interiors and furniture for more than 16 years. He has also been a highly respected design teacher and lecturer. Hutton's beautifully tailored interiors and versatile furniture have classic lines and timeless style. Here, he shares his experience and design wisdom.

Fabrics

↜ While experimentation is always a fine thing in design, it is especially important that fabrics are appropriate for their use. This is the key to design success and furniture and drapery longevity. Fine silk should last for years on pillows and padded wall coverings, but if used for upholstery or draperies in the sun it will have a short, shredded life. Formal fabrics — luxurious velvets or highly detailed prints — are dissonant in informal rooms. Overly colorful or patterned fabrics can be too "loud" for a room in which you'd like to relax. Modern textiles can be an intriguing contrast on fine antique furniture, but try one chair at a time. (Don't forget to treat upholstery and draperies with a stain repellent for extra protection.)

↜ White, cream, ivory and parchment fabrics are versatile because they don't date and can't fade. Wash them or dust them off with a vacuum every week or so. Remember — all whites and creams go together. Upholstery, heavy cotton or linen — or a blend of the two — are generally the most versatile and abrasion-resistant, and they won't rot in the sun. And cost effective because they're hard wearing, can often be washed and cleaned effectively, and they feel good to the touch.

↜ Simple, unpatterned fabrics have staying power and won't date. Strident colors and elaborate patterns are to be used judiciously. Bold patterns tend to take over a room, and get repetitious and tired-looking over time. If pattern is called for, select colors that are somewhat neutral or low-key to tone down the effect.

↜ The newest way to work with fabrics is to explore the wide range of textures — from boucle to damask, velvet, corduroy, chenille, twill, taffeta, satin, and grospoint for starters. Textures add surface interest to fabrics. And there's no problem matching patterns.

Floors

↜ Consider two major aspects of flooring first. Initially, study traffic patterns and the kind of use the floor will have. Which areas will get the most use? Which need cushioning for comfort? Second, decide what kind of decorative effect is needed.

↜ For heavy traffic, hard surfaces such as wood, vinyl, stone, or terrazzo and concrete are always best for easy maintenance and longevity. If rugs are used, be sure that they have non-slip padding underneath.

↜ Color, texture, and patterns must be considered carefully, especially in a large room. Generally, a floor needs to have some interest — texture, subtle pattern, a handsome border — to "ground" the decor. Oriental carpets, kilim rugs, dhurries, and other vintage rugs give a room character and life. They're also practical

OPPOSITE Monochromatic color schemes are soothing to the eye and versatile. They can be toned down with injections of white or revved up with bright red, orange, chartreuse, or black.

because the patterns disguise stains, and wear makes them more handsome.

꙰ While it may seem luxurious, wall-to-wall carpeting is not especially suitable for living rooms. It does offer comfort underfoot, some soundproofing, and a feeling of warmth, but in a large room the effect is monotonous and rather bland. Traffic patterns may show quickly near doorways. A more cost-effective and interesting way to cover the floor is with custom-cut textured wool, sisal, coir or jute or with maize or seagrass squares. Bound area rugs on a hardwood floor offer the best of both worlds — practicality and use.

꙰ Overly fussy, deeply sculpted and highly patterned carpets are to be avoided. They have a self-conscious, pretentious look and make a room look overwrought.

꙰ Adding a twill or tape binding to a custom-cut jute, flat-woven wool sisal, coir, or wool pile carpet gives it a more finished look. This can be done by a carpet installer.

Windows

꙰ Even before design, color, style, or materials are considered, it's important that the particular function of the window coverings are defined. Are the draperies or blinds for light control, privacy, soundproofing, decor alone, or temperature control? For light control, for example, heavy draperies should be lined and possibly also interlined. To help soundproof a room, consider having draperies interlined with flannel. (This can also keep out drafts.) Full-length draperies, shades that can be adjusted up from the window sill, or cafe curtains offer best options for privacy. New sheer metalicized fabrics used as draperies can deflect heat and cold — and keep out

as much as 25 percent of the outdoor temperature.

꙰ Experiment. There are hundreds of styles of new drapery hardware. Check stores and catalogues, such as Pottery Barn, Ballard Design, Calico Corner, hardware stores, and Home Depots.

꙰ Don't use silk for curtains that will be in direct sun. Select lovely silks for north-facing windows or for windows that are shaded by wide eaves or a verandah.

꙰ Simplicity is always the best approach. Fussy, frilly, ruffly, and elaborate draperies are such attention stealers that they distract from other details of a room. Trims, braids, and tiebacks make draperies interesting — but don't overdo them.

꙰ Roman shades give an uncluttered, tailored effect that traverse draperies won't have. Though simple, Roman shades are labor intensive and often expensive when custom-made. Check home catalogues for ready-mades.

Electronic Equipment

꙰ Sound equipment should be easily accessible and controllable. Often a simple, inexpensive system will be perfectly adequate for a "special," seldom-used living room. A simple CD player — rather than radio and the whole whizzbang works — will suffice if you spend little time — or mostly quiet time — in the living room.

꙰ Sound technology has advanced so that large speakers are unnecessary. Unobtrusive subwoofers and speakers can be concealed easily and be remarkably effective.

OPPOSITE For Sharon and Andy Gillin, designer Stephen Shubel brought together a comfortable and unexpected combination of easy chairs, small and large-scale accessories.

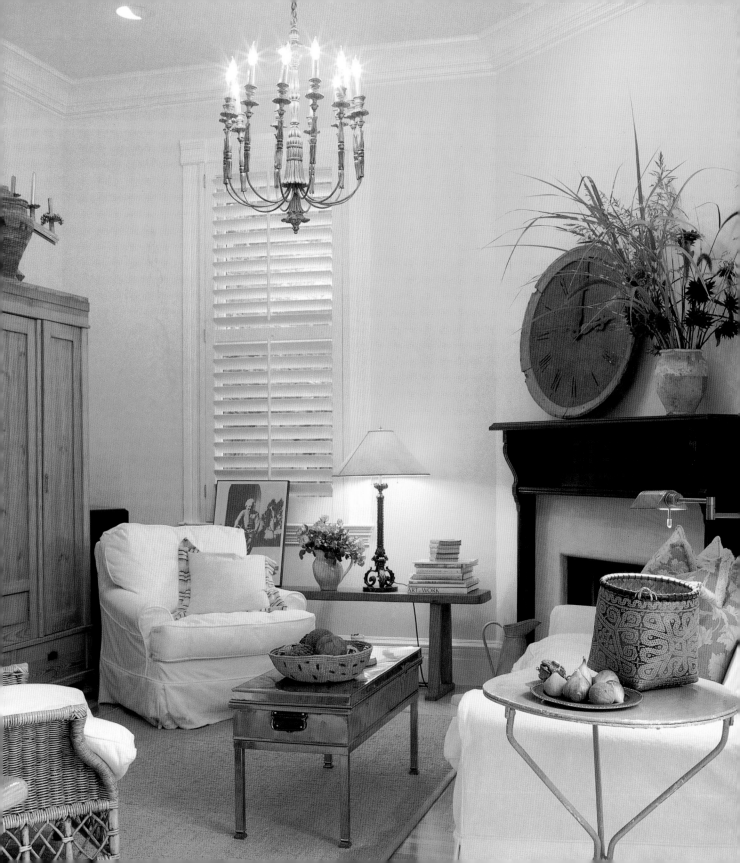

☙ When renovating, plan cabinetry in appropriate places for speakers, television, VCR, and other equipment. Install concealed wiring.

☙ There are two distinct lines of thought regarding televisions in the living room. One firmly held opinion in the design world is that televisions are a fact of life and should not be hidden away, even if they are very visible and somewhat dissonant with antiques and handsome upholstery. Other designers believe that a big black box is antithetical to sophisticated, finely detailed decor and should be banished to closets, cabinets, and armoires at all cost. Consider your tolerance level for electronics, your love (or disdain) for television, and make your own decision. For occasional use, it may be best to keep the set on a rolling cart that can be tucked away in a walk-in closet.

☙ Don't place the set too high on the shelf. And be sure to secure your television in case of earthquakes.

OPPOSITE Appearances are often deceiving. In this chic, polished Los Angeles room, Melissa Deitz welcomes her beloved dogs who love the down-filled sofa.

BELOW Peggy Knickerbocker's slipcovers: comfortable, practical.

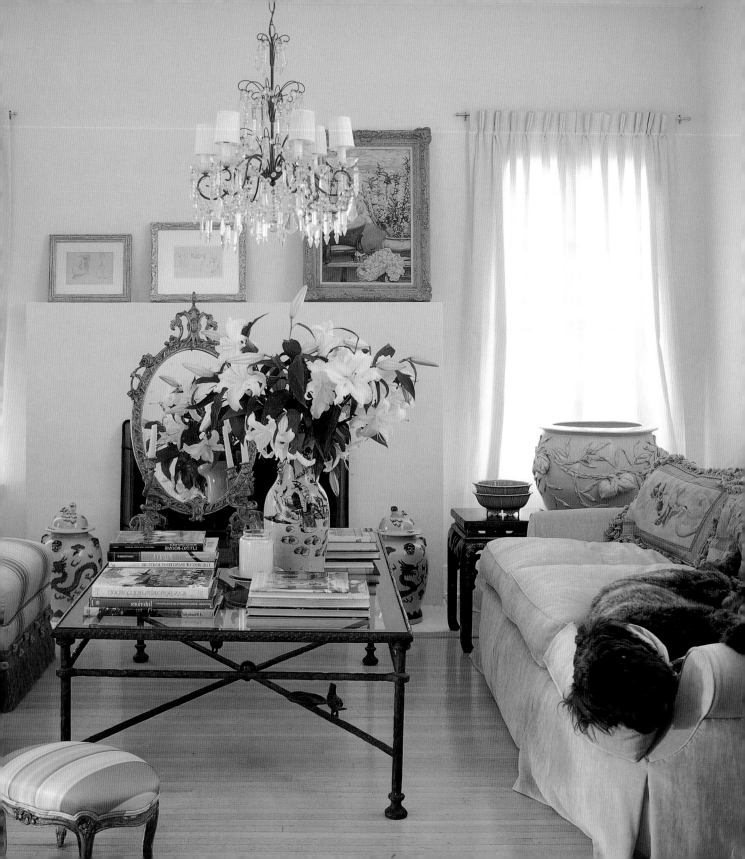

Design and style are always on the move in California — and not just because of the restless earth under our feet. Designers are itchy to venture on. The idea of living in the past or perpetuating old style stereotypes is never appealing. Best of all — for those Pacific Coast visionaries who craft furniture, fire pottery, open stores, blow glass, sew glamorous pillows, limn glorious interiors, or venture to build ground-breaking houses — Californians are an enthusiastic audience. *Diane Dorrans Saeks*

DESIGN & STYLE STORES

LOS ANGELES

Action Streets: You must have wheels, of course, to go design shopping in Los Angeles. On weekends, flea markets in Pasadena and Long Beach are lively. Best centers of style include shops on North Robertson Avenue, Melrose Avenue (the western end), all along La Brea, Larchmont, and out in Santa Monica. But part of the fun of shopping for furniture, linen sheets, silk pillows, fabrics or antiques is screeching to a halt in front of a new store on an as-yet undiscovered avenue.

AMERICAN RAG CIE MAISON ET CAFE
**148 S. La Brea Avenue
(Also in San Francisco)**
The home of California/French style with Provençal pottery, books, French furniture, kitchenware — plus a tiny cafe. Great finds.

ANICHINI
466 N. Robertson Boulevard
Bedroom glamour and luxury. Gorgeous silk-bound cashmere blankets, linen sheets, jacquard weave throws, and heirloom blankets. Delicious!

PAMELA BARSKY
**100 N. La Cienega Boulevard
(Beverly Connection)**
Changing range of decorative objects, tabletop decor with fresh wit.

BLACKMAN-CRUZ
800 N. La Cienega Boulevard
Influential — and addictive. Stylish and often odd twentieth-century objects and furniture. Clocks, architectural fragments. A big favorite with stylists, Hollywood set designers, collectors, designers.

BOOK SOUP
**8818 Sunset Boulevard
West Hollywood**
My great favorite. Must-visit bookstore, with all-day and midnight browsing. Readings. Walls of design, architecture, and photography books. Open-air magazine stand has all the international design magazines.

CITY ANTIQUES
8444 Melrose Avenue
A fine source for eighteenth-through twentieth-century furniture, some by admired but slightly obscure designers. An influential look.

NANCY CORZINE
8747 Melrose Avenue
To the trade only. Edited, elegant, suavely updated classic furnishings. Outstanding Italian fabric collection.

DIALOGICA
8304 Melrose Avenue
Smooth contemporary furniture.

DIAMOND FOAM & FABRIC
611 S. La Brea Avenue
Design insiders' favorite. Addictive. Long a secret source for well-priced fabrics, Jason Asch's bustling treasure house offers the added benefit of off-the-rack basics textiles, plus linen, chintz, silk, and damask shopping.

RANDY FRANKS
8448 Melrose Place
One-of-a-kind furniture. New designers.

HOLLYHOCK
214 N. Larchmont Boulevard
A cozy, elegant look. Fabrics, furniture, and decorative accessories for house and garden.

INDIGO SEAS
123 N. Robertson Boulevard
Noël Coward anyone? Lynn von Kersting's madly energized style: part exotic Caribbean Colonial, part south of France, part Old Idealized England. Sofas, soaps.

LA MAISON DU BAL
705 N. Harper Avenue
Exquisite antique and vintage textiles, idiosyncratic lighting, antique French furniture. Friendly atmosphere.

MODERNICA
7366 Beverly Boulevard
Modernist furniture, focusing on twenties to sixties. Reproductions.

MODERN LIVING
8125 Melrose Avenue
Goodman Charlton, Cassina, De Sede — and all the moderns.

RICHARD MULLIGAN — SUNSET COTTAGE
8157 Sunset Boulevard
To the trade only: 213–650–8660. With your decorator in tow, get seduced by the Mulligans' chic country vision. Richard and Mollie have star power — and a loyal following among Hollywood designers and celebs. Antique and vintage country-style antiques. Beautifully finessed painted reproductions and collectible one-of-a-kind lamps.

ODALISQUE
7278 Beverly Boulevard
Stars come here to hang out among the silks and pillows. Finest embroidered antique fabrics and glorious vintage textiles. One-of-a-kind pillows and draperies made from ecclesiastical, operatic fabrics.

The owners' obsession and admiration for old fabrics is catching.

PACIFIC DESIGN CENTER
8687 Melrose Avenue
Top to-the-trade showrooms, such as Mimi London, Donghia, Randolph & Hein, and Kneedler-Fauchere, present the finest fabrics, furniture, lighting, rugs, hardware, reproductions, decorative accessories, fixtures.

RIZZOLI BOOKSTORE
9501 Wilshire Boulevard
(Also 332 Santa Monica Boulevard, Santa Monica)
Top-notch selection of design and architecture books. Linger among the design book stacks. Open late.

ROSE TARLOW —
MELROSE HOUSE
8454 Melrose Place
Rose Tarlow has a great sense of furniture scale and an exquisite understanding of luxury, elegance, line, and grace. A certain Continental/English sensibility and glamour in her furniture collection.

RUSSELL SIMPSON COMPANY
8109 Melrose Avenue
Bret Witke and Diane Rosenstein sell furniture from the forties and fifties. Eames, Jacobsen, Saarinen, Robsjohn-Gibbings—like that.

THE SILK TRADING COMPANY
353–351 S. La Brea Avenue
Custom-made and colored silks for decorating. Chenille, silk, linen, velvet, damasks.

Draperies, bed linens, upholstery. Superb fabrics.

W ANTIQUES AND EXCENTRICITIES
8925 Melrose Avenue
Melissa Deitz's charming, jam-packed shop sells everything from eighteenth-century gilded chairs to birdcage-shaped chandeliers, chinoiseries, fountains, urns, art deco furniture. It's one-of-a-kind and ever changing.

SAN FRANCISCO

My favorite design shopping streets are Fillmore, Hayes, Brady, Post, Sutter, Grant, Sacramento, Polk (around Broadway), Gough, Union. Other little style scenes are all over town. For top-notch design stores, explore Fillmore Street from Pacific Avenue to Bush Street.

AGRARIA
1051 Howard Street
Telephone 415–863–7700 for an appointment. A longtime favorite. Maurice Gibson and Stanford Stevenson's classic potpourri and soaps are tops. (Also sold at Gump's.)

AMERICAN RAG CIE
1305 Van Ness Avenue
South of France in San Francisco: books, furniture, glassware, cafe and bar ware.

ANN SACKS TILE & STONE
Showplace Design Center
2 Henry Adams Street
Extensive selection of hand-crafted tiles plus stone cut in many sizes. The place for tiles by small companies, some reviving historical designs. New: "Stone" tiles in subtle colors by Ironies.

ARCH
407 Jackson Street
Architect Susan Colliver's colorful shop sells serious supplies for designers, architects, and artists. Excellent ranges of papers, frames.

BELL'OCCHIO
8 Brady Street
Tiny and worth a detour. Claudia Schwartz and Toby Hanson's enchanting boutique offers hand-painted ribbons, French silk flowers. Trips to Paris and Florence produce charming tableware, antiques, and retro-chic Italian and Parisian soaps and face powders.

CLERVI MARBLE
221 Bayshore Boulevard
This highly respected 80-year-old company sells marble, granite, onyx, travertine, limestone—all the natural stones. They also craft counters, tabletops, fireplace facings, decorative objects.

GORDON BENNETT
2102 Union Street
Garden style throughout the seasons. Vases, plants, books, candles, decoupage plates, and tools. (Ask the owner to explain

the name – and to introduce his handsome poodles.)

BLOOMERS
2975 Washington Street
Patric Powell's fragrant domain. Bloomers shines all seasons with the freshest cut flowers and orchids. Walls of vases, French ribbons and baskets. Nothing frou-frou or fussy here—just nature's beauty at its best.

VIRGINIA BREIER
3091 Sacramento Street
A gallery for contemporary and traditional American crafts.

BRITEX
146 Geary Street
Extensive home-design sections. Action-central for thousands of fabrics. World-class selections of classic and unusual furnishing textiles, trims, notions.

BROWN DIRT COWBOYS
2418 Polk Street
Painted and refurbished furniture, housewares.

CANDELIER
60 Maiden Lane
Wade Benson's virtuoso store for candles and all their accouterments. Superb collection of candlesticks, books, and tabletop decor.

CARTIER
231 Post Street
Elegant selection of crystal, vases, porcelain.

COLUMBINE DESIGN
1541 Grant Avenue
On a pioneering block of North Beach, Kathleen Dooley sells fresh flowers and gifts, along with shells, graphic framed butterflies, bugs and beetles.

THE COTTAGE TABLE COMPANY
550 18th Street
Tony Cowan custom-makes heirloom-quality hardwood tables to order. Shipping available. Catalogue.

DE VERA
334 Gough Street
A must-visit store. *Objets trouvés*, sculpture. Remarkable, original small-scale finds, and original designs by Federico de Vera.

DE VERA GLASS
384 Hayes Street
A mesmerizing gallery of vibrant glass objects by contemporary American artists, along with Venetian and Scandinavian classics. Ted Muehling jewelry.

F. DORIAN
388 Hayes Street
Treasure trove. Contemporary accessories, folk arts, and antiques.

EARTHSAKE
2076 Chestnut Street.
(Also in the Embarcadero Center, Berkeley, and Palo Alto)
Earth-friendly stores with attractive furniture, unbleached bed linens and towels, politically correct beds, vases of recycled glass, candles.

FILLAMENTO
2185 Fillmore Street
For more than a decade, a must for design aficionados. Go-go owner Iris Fuller fills three floors with colorful, style-conscious furniture, tableware, glass, toiletries, and gifts. Iris is always first with new designers' works and supports local talent, including Ann Gish, Annieglass, and Cyclamen. Frames, lamps, linens, beds, and partyware.

FIORIDELLA
1920 Polk Street
Flower-lovers alert: For more than 16 years, Jean Thompson and Barbara Belloli have been offering the most beautiful, fragrant flowers and plants. Exclusive selection of decorative accessories and versatile vases. Mexican folk crafts, orchids, furniture-in a luscious interior.

FLAX
1699 Market Street
Tasty, tempting selections of papers, lighting, tabletop accessories, boxes, art books, furnishings. One-stop shopping for art supplies. Catalogue.

FORZA
1742 Polk Street
Handcrafted furniture, candles, accessories with a certain rustic elegance. Great aesthetic.

STANLEE R. GATTI FLOWERS
Fairmont Hotel, Nob Hill
Vibrant spot for fresh flowers, Agraria potpourri, vases, and candles.

GEORGE
2411 California Street
Pet heaven. Style for dogs and cats, including Todd Oldham- and Tom Bonauro-designed charms, toys, pillows, bowls, and accessories. Best dog treats: whole-grain biscuits.

GREEN WORLD MERCANTILE
2340 Polk Street
Serious owners sell earth-friendly housewares, clothing, gardening equipment, plants, books, and unpretentious decorative accessories.

GUMP'S
135 Post Street
Geraldine Stutz has dreamed up the new Gump's — with beautifully displayed crafts, fine art, Orient-inspired accessories, plus timeless crystal and elegant linens and tableware. Recent refurbishing makes the store an essential stop. Be sure to visit the silver, Treillage, jewelry and decorative glass departments. Catalogue.

RICHARD HILKERT BOOKS
333 Hayes Street
Hushed, like a private library. Decorators and the book-addicted telephone Richard to order out-of-print style books and new design books. Browsing here on Saturday afternoons is especially pleasant.

INDIGO V
1352 Castro Street
Diane's fresh flowers are quirky, original. A neighborhood favorite.

IN MY DREAMS
1300 Pacific Avenue
Jewelry designer Harry Fireside's (and chums') dreamy shop for antiques, topiaries, and Chinese lanterns.

JAPONESQUE
824 Montgomery Street
Aesthete Koichi Hara demonstrates his appreciation of tradition, harmony, simplicity, humble materials. Japanese graphics, sculpture, glass, furniture.

JUICY NEWS
2453 Fillmore Street
A local haunt for every possible design, architecture, and style magazine — and fresh fruit juices.

KRIS KELLY
One Union Square
Selections of beds, linens, and table linens.

SUE FISHER KING
3067 Sacramento Street
Sue King's Italian, French and English bed linens and tableware are the most luxurious and

prettiest. Luxurious blankets, plus accessories, books, soaps, furniture, and silk and cashmere throws.

LIMN
290 Townsend Street
Lively stop on Saturday afternoons. Contemporary furniture, accessories, and lighting by over 300 manufacturers. Well-priced, take-out collections, along with Philippe Starck, Andree Putman, and Mathieu & Ray for Ecart, plus top Northern California talent. Visit the new gallery behind the store.

DAVID LUKE & ASSOCIATE
773 14th Street
Antiques, vintage furniture, old garden ornaments—some of them from the estates of England. (David's pooch is the associate.)

MAC
1543 Grant Avenue
Chris Ospital's trend-setting salon sells style inspiration. Stop and chat: Talent-spotter Chris knows what's new, when, where.

MACY'S
Union Square
Growing and expanding. Furniture and accessories floors display a popular selection of furnishings. Interior Design Department has designers available to assist with decorating. Simply elegant: Calvin Klein Home. Also a well-stocked marketplace offering tableware, kitchenware, and kitchen tools.

MAISON D'ETRE
92 South Park
In a new Toby Levy–designed building, ever-changing collections of vintage furniture, lighting, handblown glass bowls, vases, candles. Presented with spirit.

MIKE FURNITURE
Corner of Fillmore and Sacramento streets
With design directed by Mike Moore and partner Mike Thackar, this spacious, sunny store sells updated furniture classics-with-a-twist by Beverly and other manufacturers. Good design here is very accessible. One-stop shopping for fast-delivery sofas, fabrics, lamps, tables, fabrics, accessories.

NAOMI'S ANTIQUES TO GO
1817 Polk Street
Collectors throng here for art pottery! Bauer and Fiesta, of course, plus historic studio pottery. American-railroad, airline, luxury-liner, and bus-depot china.

NEST
2300 Fillmore Street
Where a neighborhood pharmacy stood for decades, Marcella Madsen and Judith Gilman have feathered a new Nest. Seductive treasures include books, silk flowers, rustic antiques, prints, sachets, and pillows.

PAINT EFFECTS
2426 Fillmore Street
Paint experts Sheila Rauch and partner Patricia Orlando have a loyal following for their range of innovative paint finishes and tools. Hands-on paint technique classes by Lesley Ruda and Michele Trufelli, along with materials for gilding, liming, crackle glazing, decoupage, stenciling, and other decorative finishes.

PAXTON GATE
1204 Stevenson Street
Authentic butterfly nets, anyone? Peter Kline and Sean Quigley's gardening store offers uncommon plants (such as sweetly scented Buddha's Hand citron trees), plus orchids, vases, and hand-forged tools.

POLANCO
393 Hayes Street
For certain uplift, see these superbly presented Mexican fine arts, photography, and crafts. Museum curator Elsa Cameron says you can't find better in Mexico.

POLO RALPH LAUREN
Corner of Post and Kearney streets, Crocker Galleria
Ralph Lauren's striking new emporium purveys his complete Home collection. Best-quality furniture, linens, and the trappings of fine rooms, luxurious apartments, country houses.

PORTOBELLO
3915 24th Street
A tiny treasure. Old furniture in new guises, kilims, decorative objects.

POTTERY BARN
**The Marina
(Also in Embarcadero Center, Stonestown, Burlingame, Palo Alto, Corte Madera)**
The San Francisco-based company has stores all over California. New full-service design stores offer furniture, rugs, draperies, special orders. Practical, well-priced home style. Excellent basics. Classic, accessible design. Catalogue.

RAYON VERT
3187 16th Street
Well worth the trek to the Mission. Floral designer Kelly Kornegay's garden of earthly delights. Porcelains, flowers, artifacts, glasses, architectural fragments in a full-tilt, humble-chic setting.

RH
2506 Sacramento Street
Rick Herbert's sunny garden and tableware store has beeswax candles, dinnerware by Sebastopol artist Aletha Soule. Inspiring selection of sconces, cachepots, vases. Topiaries, too.

RIZZOLI BOOKS
117 Post Street
New, next to Gump's. Elegant book-lovers' paradise. Outstanding collection of design, architecture, and photography books. Cafe.

SAN FRANCISCO DESIGN CENTER GALLERIA AND SHOWPLACE
Henry Adams Street
It is wise to come to this South of Market design center with your decorator. A professional's eye can lead you to the best sofas, trims, silks, accessories, fabrics. These to-the-trade-only buildings—along with Showplace Square West and other nearby showrooms—offer top-of-the-line furniture, fabrics, and furnishings. Randolph & Hein, Kneedler-Fauchere, Sloan Miyasato, Shears & Window, Clarence House, Palacek, Brunschwig & Fils, Schumacher, Therien Studio, Stephen Michael, McRae Hinckley, Donghia, Summit Furniture, Clarence House, Enid Ford, and Houlès are personal favorites. Also in the neighborhood: Therien & Co (Scandinavian, Continental, and English antiques) and the handsome Palladian outpost of Ed Hardy San Francisco (eclectic antiques and worldly reproductions).

SATIN MOON FABRICS
32 Clement Street
Twenty-four-year-old store sells a well-edited collection of decorating linens, trims, chintzes, and well-priced fabrics.

SCHEUER LINENS
340 Sutter Street
Longtime well-focused store for fine-quality bed linens, blankets. This staff facilitates custom orders particularly well.

SHABBY CHIC
3075 Sacramento Street
(Also in Santa Monica)
Specializes in chairs and sofas with comfortable airs and loose-fitting slipcovers. Lasting quality.

WILLIAM STOUT ARCHITECTURAL BOOKS
804 Montgomery Street
Architect Bill Stout's chock-a-block book store specializes in basic and obscure twentieth-century architecture publications, along with new and out-of-print design and garden books. Catalogues.

SUE FISHER KING HOME AT WILKES BASHFORD
375 Sutter Street
Glamour galore. Sue's dynamic merchandise includes tableware, accessories, glass, pillows, linens, furniture, and special *objets d'art* from Italy, France, London. Books.

TIFFANY & CO
350 Post Street
Try on a diamond ring or a Paloma Picasso necklace, then head upstairs to the venerated crystal, china, and silver departments. Ask about Elsa Peretti's classic glasses, bowls, and silver.

WATERWORKS
235 Kansas Street
Bath fixtures, tile, and stone.

WILLIAMS-SONOMA
150 Post Street
Bustling flagship for the Williams-Sonoma cookware empire. Stores throughout the state, including Corte Madera, Palo Alto, Rodeo Drive, Pasadena. Delicacies. Outstanding basics for serious and dilettante cooks. Catalogues.

WORLDWARE
336 Hayes Street
Enduring classic design. Shari Sant's eco-store sells cozy unbleached sheets and blankets, vintage-wear, and such delights as patchwork pillows, *de luxe* candles. Interiors crafted by Dan Plummer from recycled materials. Catalogue.

ZINC DETAILS
1905 Fillmore Street
The vibrant Zinc Details shop has a cult following. Architect-designed and handcrafted furniture, lighting. Extraordinary hand-blown glass vases by international artists. Domain of Wendy Nishimura and Vasilios Kiniris. (No, they don't sell anything made of zinc.)

ZONAL HOME INTERIORS
568 Hayes Street
Visit Hayes Valley and visit Russell Pritchard's pioneering gallery store of one-of-a-kind rustic furniture and decorative objects. He made the patina of rust and the textures of loving use fashionable. Old Americana at its best.

Much of the design store action here is focused on wonderfully revived Fourth Street. We recommend, too, a detour to Cafe Fanny, the Acme Bread bakery, Chez Panisse, and shops in the Elmwood.

BERKELEY MILLS
2830 Seventh Street
Handcrafted fine Japanese- and Mission-influenced furniture. Blends the best of old-world craftsmanship with high-tech. All built to order. Catalogue.

BUILDERS BOOKSOURCE
1817 Fourth Street
Well-displayed design, architecture, gardening, and building books.

CAMPS AND COTTAGES
2109 Virginia Street
First lunch at Chez Panisse or Berkeley's beloved Cheese Board, then walk here for a visit. This little shop sells charming homey furniture and low-key accessories. Owner Molly Hyde English has perfect pitch.

CYCLAMEN STUDIO
1825 Eastshore Highway
Restless designer Julie Sanders' colorful ceramics seconds—with barely discernible flaws—are available at this factory store. Broad range of designs. (Her vibrant Cyclamen Studio designs are featured at Fillamento, Henri Bendel.)

ELICA'S PAPERS
1801 Fourth Street
Eriko Kurita's eight-year old shop specializes in Japanese handmade papers. The store custom-makes stationery, albums, frames, paper wallhangings, decorative boxes, sketchbooks. The most intriguing papers are made from mulberry bark. Papers can be used for making lamp shades, window shades, screens, even wallpaper.

THE GARDENER
1836 Fourth Street
Pioneer Alta Tingle's brilliant, inspired garden store sells tools, vases, books, tables, chairs, tableware, paintings, clothing, and food for nature-lovers — whether they have a garden or are just dreaming. Consistently original, classic style.

LIGHTING STUDIO
1808 Fourth Street
Lighting design services. Contemporary lamps.

THE MAGAZINE
1823 Eastshore Highway
A top resource for contemporary furniture. Artemide, Kartell, Aero, Cappellini, Flos, Italiana Luce, and many others.

SUR LA TABLE
1806 Fourth Street
Outpost of the 24-year-old Seattle cookware company but feels entirely original. In a 5,000-square-foot "warehouse," the shop stocks every imaginable kitchen goodie, gadget, tool, utensil, plate, machine and decoration for serious and dilettante cooks. Catalogue.

TAIL OF THE YAK
2632 Ashby Avenue
Chic partners Alice Hoffman Erb and Lauren Adams Allard have created a magical mystery show that is always worth the trip — across the bay or across the country. Decorative accessories, wedding gifts, Mexican furniture, fabrics, ribbons, notecards, Lauren's books, tableware, and antique jewelry.

ERICA TANOV
1627 San Pablo Avenue
The place for pajamas, romantic accessories. Erica's lace-edged sheets and shams and linen duvet covers are quietly luxurious. (Drop in to Kermit Lynch Wine Merchants, Acme Bread, and Cafe Fanny just up the street.)

URBAN ORE
1333 Sixth Street
One city block of architectural details from salvaged buildings, plus old furniture, books, tools, and fixtures.

ZIA
1310 Tenth Street
Collin Smith's sun-filled gallery store offers a changing variety of hands-on furniture designs and art.

BIG SUR

THE PHOENIX
Highway 1
An enduring store where you can linger for hours. Collections of handcrafted decorative objects, wind chimes, glass, books, sculpture, jewelry, hand-knit sweaters by Kaffe Fassett (who grew up in Big Sur), and toys. Coastal views from all windows. Be sure to walk downstairs. Crystals, soothing music, and handmade objects are on all sides. The sixties never truly left Big Sur — thank goodness.

BURLINGAME

SAMANTHA COLE
1436 Burlingame Avenue
Smoothly executed traditional style, with a light hand. Decor for comfortable interiors.

CALISTOGA

THE TIN BARN
1510 Lincoln Avenue
Antiques dealer Al Dobbs (along with Eric Cogswell and Max King) has put together a stylish collection of Arts & Crafts furniture, fifties ceramics, garden ornament, Indian rugs, desirable accessories, and vintage finds.

CARMEL

CARMEL BAY COMPANY
Corner of Ocean and Lincoln
Tableware, books, glassware, furniture, prints.

FRANCESCA VICTORIA
250 Crossroads Boulevard
Decorative accessories for garden and home. Fresh style.

LUCIANO ANTIQUES
San Carlos and Fifth streets
Cosmopolitan antiques. Wander through the vast rooms — to view furniture, lighting, sculpture, and handsome reproductions.

PLACES IN THE SUN
Dolores Avenue near Ocean Avenue
Decor from sun-splashed climes. Provençal tables, Mexican candlesticks, colorful fabrics.

HEALDSBURG

JIMTOWN STORE
6706 State Highway 128
Drive or bike to J. Carrie Brown and John Werner's friendly country store in the Alexander Valley. The Mercantile & Exchange vintage Americana is cheerful and very well priced. Comestibles.

MENLO PARK

MILLSTREET
1131 Chestnut Street
Objects of desire. Continental antiques, Ann Gish bed linens and silks, Tuscan pottery, tapestries, orchids, mirrors, botanical prints, silk and cashmere throws.

MENDOCINO

THE GOLDEN GOOSE
Main Street
An enduring favorite—superb linens, antiques, tableware—overlooking the ocean. For more than a decade, the most stylish store in Mendocino. (When in Mendocino, be sure to make a dinner reservation at Cafe Beaujolais and to visit WilkesSport.)

MILL VALLEY

CAPRICORN ANTIQUES & COOKWARE
100 Throckmorton Avenue
This quiet, reliable store seems to have been here forever. Basic armoires, cookware, along with antique tables, chests, and cupboards.

PULLMAN & CO.
108 Throckmorton Street
Style inspiration. Understated but luxurious bed linens (the standouts are those by Ann Gish), along with furniture, frames, tableware, and accessories.

SMITH & HAWKEN
35 Corte Madera Street
The original. Superb nursery (begun under horticulturist Sarah Hammond's superb direction) and store. Everything for gardens. Also in Pacific Heights, Berkeley, Palo Alto, Los Gatos, Santa Rosa, and points beyond. Catalogue.

SUMMER HOUSE GALLERY
21 Throckmorton Street
Impossible to leave empty-handed. Artist-crafted accessories and (to order) comfortable sofas and chairs. Witty handcrafted frames, glassware, candlesticks, and colorful accessories. Slipcovered loveseats. Vases, tables, linens, and gifts.

MONTECITO

PIERRE LAFOND/ WENDY FOSTER
516 San Ysidro Road
Handsomely displayed household furnishings, books, accessories, and South American and Malabar Coast furniture. Beautiful linens.

OAKLAND

MAISON D'ETRE
5330 College Avenue
Indoor/outdoor style. Engaging, eccentric, and whimsical decorative objects and furniture for rooms and gardens.

PALO ALTO

BELL'S BOOKS
536 Emerson Street
An especially fine and scholarly selection of new, vintage, and rare books on every aspect of design, gardens, and gardening. Also literature, books on decorative arts, photography, cooking.

HILLARY THATZ
Stanford Shopping Center
An embellished view of the cozy interiors of England, as seen by Cheryl Driver. Traditional accessories, furniture, frames, and decorative objects. Beautifully presented garden furnishings.

POLO RALPH LAUREN
Stanford Shopping Center
A spacious, gracious store. The expanding world imagined through Ralph Lauren's Anglophile eyes. Outstanding selection of furniture, imaginary heritage accessories, and quality housewares. Catalogue.

TURNER MARTIN
540 Emerson Street
David Turner and John Martin's one-of-a-kind style store/gallery.

PASADENA

HORTUS
284 E. Orange Grove Boulevard
Superbly selected perennials, antique roses, and a full nursery. Handsome collection of antique garden ornament.

SAN ANSELMO

MODERN i
500 Red Hill Avenue
Worth the drive. Steven Cabella is passionate about modernism and time-warp mid-century (1935–1965) furnishings. Vintage furnishings, Eames chairs, furniture by architects, objects, and artwork. Located in a restored modernist architect's office building.

SAN RAFAEL

MANDERLEY
By appointment: 415–472–6166. Ronnie Wells' full-tilt glamorous silk shams, antique fabrics, and vintage pillows set trends. Outstanding throws in one-of-a-kind textiles.

ST. HELENA

BALE MILL CLASSIC COUNTRY FURNITURE
3431 North St. Helena Highway
Decorative and practical updated classic furniture in a wide range of styles. A favorite with decorators.

ST. HELENA ST. HELENA ANTIQUES
1231 Main Street
(Yes, the name is intentionally repetitious.) Rustic vintage wine paraphernalia, ceramics, vintage furniture.

TANTAU
1220 Adams Street
Charming atmosphere. Decorative accessories, hand-painted furniture, gifts.

TESORO
649 Main Street
Fresh-flower heaven. Topiaries, wreaths, vases, too.

TIVOLI
1432 Main Street
Tom Scheibal and partners have created another winner, an indoor/outdoor garden furniture and accessories store. Tables and chairs and useful occasional pieces are in iron, aluminum, concrete, and recycled redwood. Antique garden ornament.

VANDERBILT & CO.
1429 Main Street
Stylish and colorful tableware, bed linens, books, glassware, Italian ceramics, accessories. A year-round favorite in the wine country. Always cheerful.

SANTA MONICA

THOMAS CALLAWAY BENCHWORKS, INC.
2929 Nebraska Avenue
By appointment only: *310–828–9379.* High-energy interior designer Thomas Callaway offers star-quality arm chairs, sofas, and ottomans with deep-down comfort and regal glamour. These are future heirlooms, very collectible.

HENNESSY & INGALLS
1254 Third Street, Promenade
Architects and designers flock to this book store, which specializes in the widest range of architectural books.

IRELAND-PAYS
2428 Main Street
Producer Kathryn Ireland and actor Amanda Pays (*Max Headroom*) created *le style anglais* for Anglophile Angelenos. Special pillows.

JASPER
1454 Fifth Street
Young interior designer Michael Smith's brilliant store and atelier. In a coolly elegant former art gallery, the high-ceilinged shop displays changing vignettes of antiques, linens, cashmeres, art glass, and Smith's own designs. Worth a detour from Paris, Chicago, Venice, wherever.

LIEF
1010 Montana Avenue
Elegant pared-down Gustavian antiques and simple Scandinavian Biedermeier

are a refreshing change from Fine French Furniture.

ROOM WITH A VIEW
1600 Montana Avenue
Kitchenware, children's furnishings, and especially glamorous bed linens by the likes of Cocoon (silks), Bischoff, and Anichini.

SHABBY CHIC
1013 Montana Avenue
Yes, they still do great smooshy sofas, but they've also moved on to tailored upholstery and a new line of fabrics.

SONOMA

SLOAN AND JONES
147 E. Spain Street
Ann Jones and Sheelagh Sloan run and stock this splendid antiques and tableware store. Set in a fine old turn-of-the-century building, it's the place for country and porcelains, silverware, Asian vintage furniture, photography, linens, and garden accessories.

THE SONOMA COUNTRY STORE
165 W. Napa Street
Ann Thornton's empire also includes her store at 3575 Sacramento Street, San Francisco. Decorative accessories, linens. Great for Christmas decorations and gifts.

TIBURON

RUTH LIVINGSTON DESIGN
72 Main Street
Interior designer Ruth Livingston's design store, with elegant selections of furniture, art, fabrics. This is also an atelier for her furniture designs.

VENICE

BOUNTIFUL
1335 Abbott Kinney Boulevard
By appointment only: *310–450–3620.* Great Edwardian and Victorian painted furniture, lamps, old beds, eccentric and glorious *objets.*

CATALOGUE PHOTOGRAPHS
A footstool by Michael Taylor Designs; a metal-and-wood chair by Donghia; a teak chair by Orlando Diaz-Azcuy for McGuire; a mahogany taboret by Peter Gutkin; a hand-painted platter by Susan Eslick; a console table by Bradford Stewart & Co; a new chair design by Orlando Diaz-Azcuy for McGuire; a pedestal and urn by Michael Taylor Designs; a new granite-topped moire table by Orlando Diaz-Azcuy for McGuire.

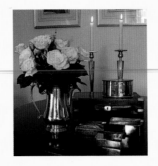

ACKNOWLEDGMENTS

Warmest thanks to California's finest photographers, whose beautiful images grace these pages.
I would especially like to thank Grey Crawford for the elegant cover photo. It has also been a pleasure
working with Jeremy Samuelson, Alan Weintraub, Christopher Irion, David Livingston,
Mark Darley, David Wakely, Andrew McKinney, Thomas Heinser, and Fred Lyon.

It has been my great joy to interview California's top interior designers
concerning many aspects of this book. I am delighted to show their work in this book—
and demonstrate the variety and quality of design in California. I send all of the designers
and talented craftspeople my deepest gratitude. I applaud their dedication and wisdom.

Madeleine Corson's beautiful book design presents my words and
each image with clarity and grace. I thank her. Special thanks to Terry Ryan,
brilliant editor, and her trusty Black Wings.

My wonderful editor, Nion McEvoy, has enthusiastically supported my ideas
for a series of design books. To Nion, along with Christina Wilson, Christine Carswell,
Pamela Geismar, and the team at Chronicle Books, I offer sincere thanks.

With love and gratitude,
Diane Dorrans Saeks

⌁

AUTHOR

Diane Dorrans Saeks is a writer, editor, and design lecturer who specializes
in interior design, architecture, gardens, travel, and fashion. She is the California editor
for *Metropolitan Home,* a contributing editor for *Garden Design,* San Francisco correspondent
for *W* and *Women's Wear Daily,* and a frequent contributor to the *San Francisco Chronicle.*
Her articles have appeared in magazines and newspapers around the world, including
Vogue Living, Vogue Australia, In Style, the *New York Times,* the *Washington Post,*
the *Los Angeles Times,* the *London Times,* and the *Sydney Morning Herald.* She is also the
author of *California Design Library: Kitchens* and several best-selling books on style, decor,
and design, including *California Cottages, San Francisco Interiors, San Francisco: A Certain Style*
and *California Country,* all published by Chronicle Books. She lives in San Francisco.